Acrylics
Unleashed

Dedication

This book is for YOU, lovely artist!

Acrylics Unleashed

Glyn Macey

Search Press

Acrylics Unleashed

First published in Great Britain 2013

Search Press Limited
Wellwood, North Farm Road,
Tunbridge Wells, Kent TN2 3DR

Reprinted 2013

Text copyright © Glyn Macey 2013

Photographs by Paul Bricknell at Search Press Studios
Additional art and portrait photography by Bob Berry
Photographs and design copyright
© Search Press Ltd 2013

ISBN: 978-1-84448-796-7

The Publishers and author can accept no responsibility
for any consequences arising from the information,
advice or instructions given in this publication.

Readers are permitted to reproduce any of the items in
this book for their personal use, or for the purposes of
selling for charity, free of charge and without the prior
permission of the Publishers. Any use of the items for
commercial purposes is not permitted without the prior
permission of the Publishers.

Suppliers
For details of suppliers, please visit the
Search Press website:
www.searchpress.com.

You are invited to the author's website:
www.glynmacey.com

Publisher's note
All the step-by-step photographs in this book feature
the author, Glyn Macey, demonstrating acrylic
painting. No models have been used.

Printed in China

Acknowledgments

Many thanks and much appreciation to Edd,
Roz, Paul and the team at Search Press; to
Sally and her lovely girls at *The Artist*; to Liz Drake,
Mitch Adams, Bob Berry, Jay Kay, Chris Williams,
Chris Packham and Julian Smith; and to Ilka, Allia,
Robbo, Clive, Steve, Neil and all of my friends
at ColArt who are busily producing the best art
materials on the planet!

To all my lovely artist friends around the world
and to those I have yet to meet!

Most of all, my biggest kisses and cuddles are for
my wife Kerry and our two tiddlers. xxx

Contents

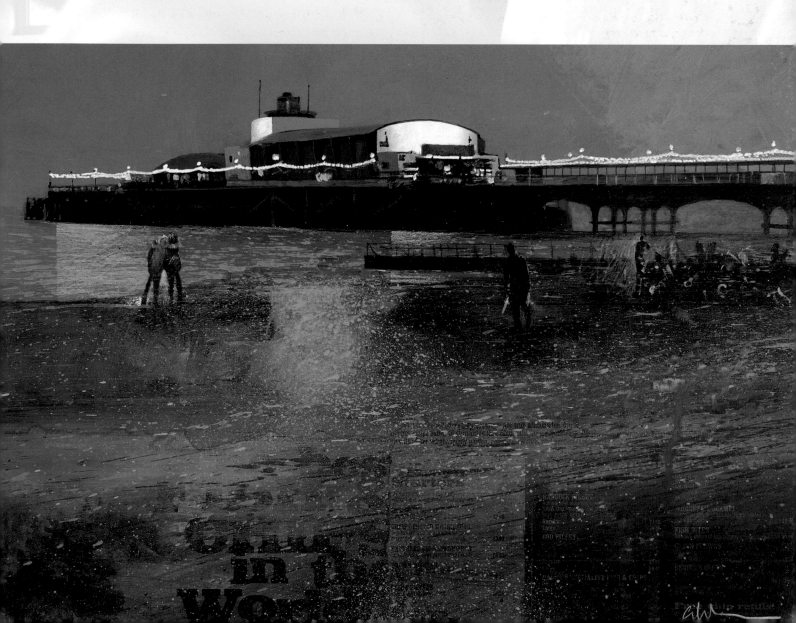

Introduction

I often find myself at a dead end when it comes to painting. It can be distressing, or at least annoying. These dead ends, cul-de-sacs and brick walls usually appear when I find myself working in a matter-of-fact, traditional kind of way. They appear when I am working with watercolour on watercolour paper and I have pushed the medium as far as I can; and I sometimes encounter the same problem with oils on canvas – fantastic as they are, they can only go so far.

At times such as these I break rank and mix it all up: oils, watercolours, pastels, inks, papers, collages, sand, stone, wood, bits of old plastic and earth. I mix it all up in the style of a child at school, for when did children ever worry about the kind of paper they were painting on? Or which kinds of brush and paint they were using? Children just go for it: they get the message down; the image, the story that they want to tell. They get it down using whatever is to hand, with absolutely no concept of what materials should traditionally be used with which supports, or the finer points of brush maintenance.

By watching my own children busily and happily making their pictures, I am constantly learning new techniques and new ways of applying paint. Why not cover a tangerine in yellow paint and roll it across the surface of your paper? 'You should do this Dad, it looks like the sand on the beach,' I am told – and it does. So why not? Being a so-called grown-up does not stop me painting like a child should the mood take me. After all, Picasso once said, 'I have spent my entire life trying to paint like a child again' and Picasso did some pretty good stuff!

Let's go for a wander down the sometimes meandering path of creative painting. On our way we will meet acrylic paint, collage and mark-making tools of all kinds. Sometimes this path will be challenging, often this path will be exciting and it will always be fun. I can not guarantee that this book will turn you into the next Picasso, but I can guarantee that if you apply even just a handful of the techniques, your work will be enriched, will have a new spark, and will have a fresh life of its own.

Windbreaks
This painting uses simple techniques and found materials for a striking result.

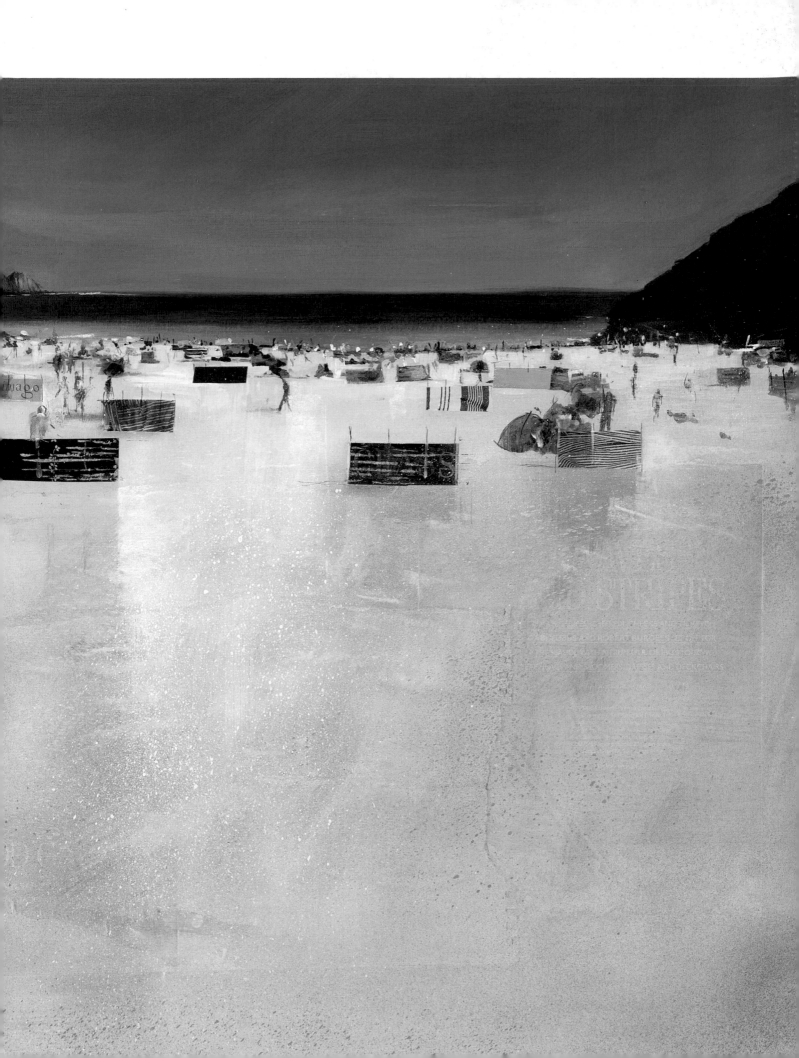

Materials

When working on location I am often asked by curious passers-by, 'Why do you choose to use acrylics in preference to other media?' I always reply:

'Because painting with acrylics is like working with slippy, slidey mud. I can spread it around with my hands. Compared with oils it dries quickly, compared with watercolours it dries slowly, it is tactile, it is forgiving, I love acrylics and acrylics love me ...' At this point, some passers-by scurry away quickly, others simply look at me bemused. But as I am now on an excited roll, I will go on to say '... and acrylics can be overpainted, I can work light over dark, I can glaze, I can scumble, I can mix sand, stones, bits of twig, grass, seaweed and earth into the paint; I can carve, I can manipulate, I can spread, flick, drip and splatter the paint.'

'That's why!' I finally finish.

Acrylic paint

Acrylics are a fast-drying paint in which the pigments are suspended in acrylic polymer emulsion. They can easily be mixed with water for washes and glazes and yet dry to a water-resistant finish. Both traditional watercolour and oil techniques can be used with acrylics (and a cheeky combination of both gives great results), and acrylics have unique techniques that are only really available to this medium, many of which are discussed in detail in this book.

No other medium is as versatile as acrylics, and for me that explains its sheer beauty. One of the many benefits of acrylics is that you can buy them in all states of viscosity from water-like liquid acrylic such as Liquitex to thick, buttery paint like Winsor & Newton Artists' Acrylic range. In between these class leaders are many other brands and many other formulations, and each gives its own startling performance. Personally I still love good old students' quality Galeria for its looseness; its 'not-quite-set-custard' consistency, and its glazing capabilities. in addition, when I was a student it was affordable and so now it holds a special place in my heart.

Above all else though, the absolute, top-drawer, class-of-its-own virtue of acrylic paint is its friendliness towards other media, particularly how well it works with different surfaces. Watercolours tend to shy away from enjoying the company of full-on mixed media, working well only on watercolour paper; and oil merely looks down from its lofty heights at anything other than the finest Belgian linen. Meanwhile, acrylics creep in through the back door, under the radar and have a wild party with anyone and anything that crosses their path. Acrylics are best friends with everyone; they work well with MDF, paper, board, canvas, stone, wood or walls and regularly hang out with pencils, collage, rubbish, tat and ephemera of all kinds – and I love that attitude.

A variety of acrylic paints in tubes. See page 18 for more information on my favourite choices for a palette of paints.

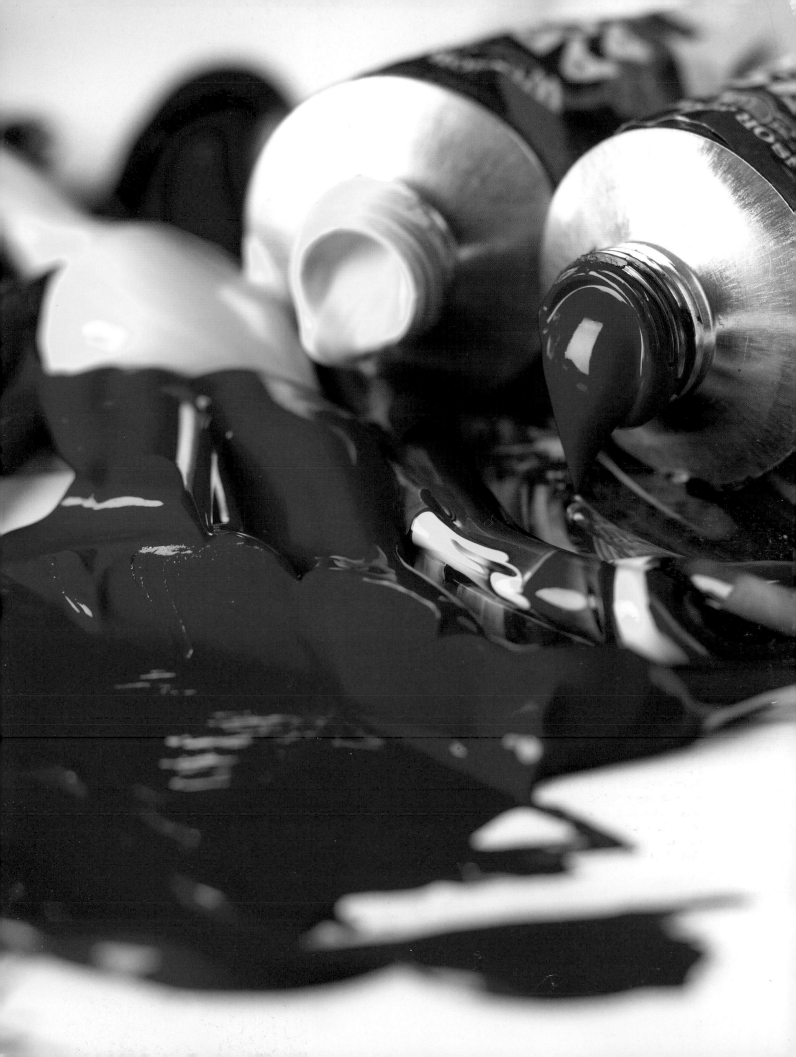

Brushes

Brushes are a curious item for me. While conventional advice will advise you to buy the best brushes you can afford (and for media such as watercolour this is true), for a more experimental approach to working with acrylics have a rummage around in your garage instead and have a little fun with those old emulsion brushes.

Some artists – quite rightly – worry over the quality and care of their brushes as if they were children: brushes can be incredibly expensive and it is only right to take great care of such an investment. I, on the other hand, tend to use whatever brushes are in my immediate vicinity. These may occasionally be beautiful handmade sables, but more likely they will be cheap, throwaway brushes from the local DIY store – the sort of brushes that you can buy in packs of five very cheaply.

What I love about these brushes is that I get to lose all sense of worry about how I treat them; I can scumble and scrape the brush over the painting surface, safe in the knowledge that I am not ruining an expensive piece of craftsmanship. I also love the loss of control that scrappy old brushes bring: the filaments might spring out at odd angles and create marks that beautiful brushes can not make. For me, the unpredictability of using old and cheap brushes means that the painting gets a little life of its own, instead of merely being a result of the precise marks that the artist consciously tries to make.

I do love brushes that can hold a lot of colour, so the bigger the better for my style of work. I never use anything smaller than a 50mm (2in) brush for those all-important initial marks, and will often use 15cm (6in) household brushes for covering areas quickly.

'But what about the small details?' I hear you ask. 'How do you paint people, masts on boats and leaves on trees?' I do keep a few small good-quality brushes for the finer details, but even these I use sparingly. I have some tricks up my sleeve for detailing which do not involve brushes at all – and I will share my tricks with you in the next few pages.

You can use whichever brushes you like, but if you want a set just like I used for the projects in this book then look for (right, from top to bottom) a 25mm (1in) round varnishing brush, 50mm (2in) and 32mm (1½in) household brushes, a size 8 flat hog, a size 28 short flat/bright, a size 2 round, a size 8 short flat, a size 2 filbert and a size 8 round brush.

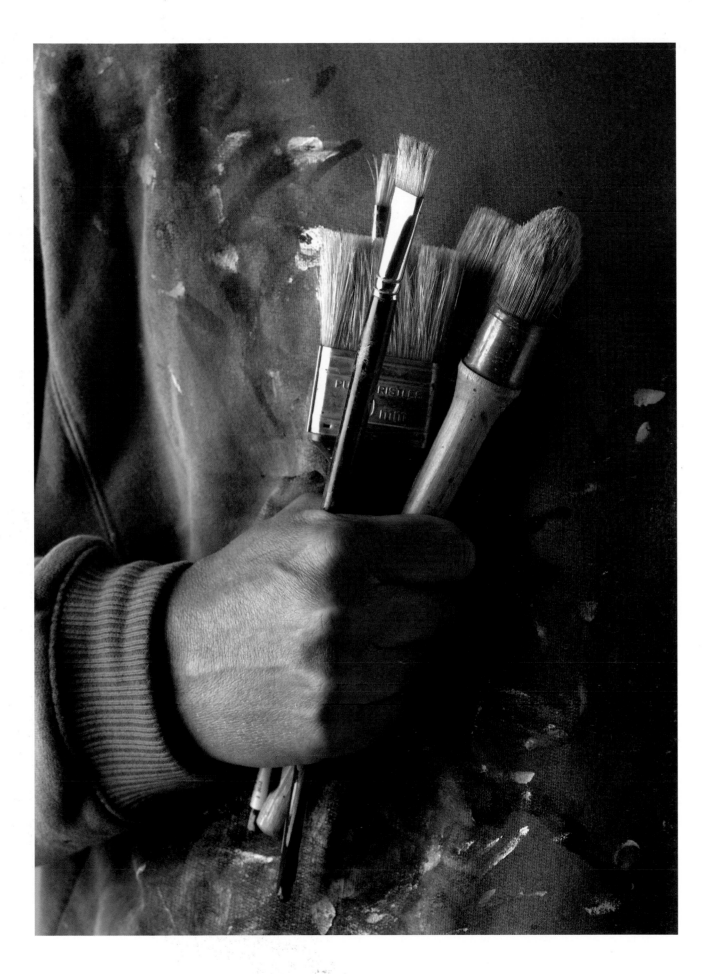

Mark-making tools

A good quality paintbrush is wonderful, but it pays to remember that brushes are far from indispensable, and that you can create fantastic artwork without using them at all.

Ink

I use bottled liquid inks and watersoluble ink pencils, both of which are really useful to combine with acrylics. Ink can be applied either with a pen – making it very useful for sketches – or with a brush. You can even smudge it in with your finger for interesting effects.

It is worth bearing in mind that some inks are watersoluble. Check which sort you are using before adding a watercolour wash to a painstakingly executed ink drawing!

Pigment sticks

This covers any stick that can be used to make a mark, particularly when I am looking to make a light mark over a dark. My collection includes chalk pastels, beautiful Conté sticks (which have a very high pigment content), coloured pencils and even children's colouring crayons, which are able to give me a useful wax resist.

Pencils

I constantly use pencils for sketching and always use B grade soft pencils, ideally 4B as these little guys give me the rich, dark line that I crave but are not so soft or black as to be unresponsive.

I use coloured pencils in both watersoluble and water-resistant types for adding details. Both are useful for sketching or adding scribbled details. Watersoluble pencils are very useful for adding temporary details to your paintings – such as grids – as the marks they make can be wiped away with a damp sponge.

Left, from top to bottom: Indian ink, Conté sticks, watersoluble pencils, coloured pencils, soft graphite pencil.

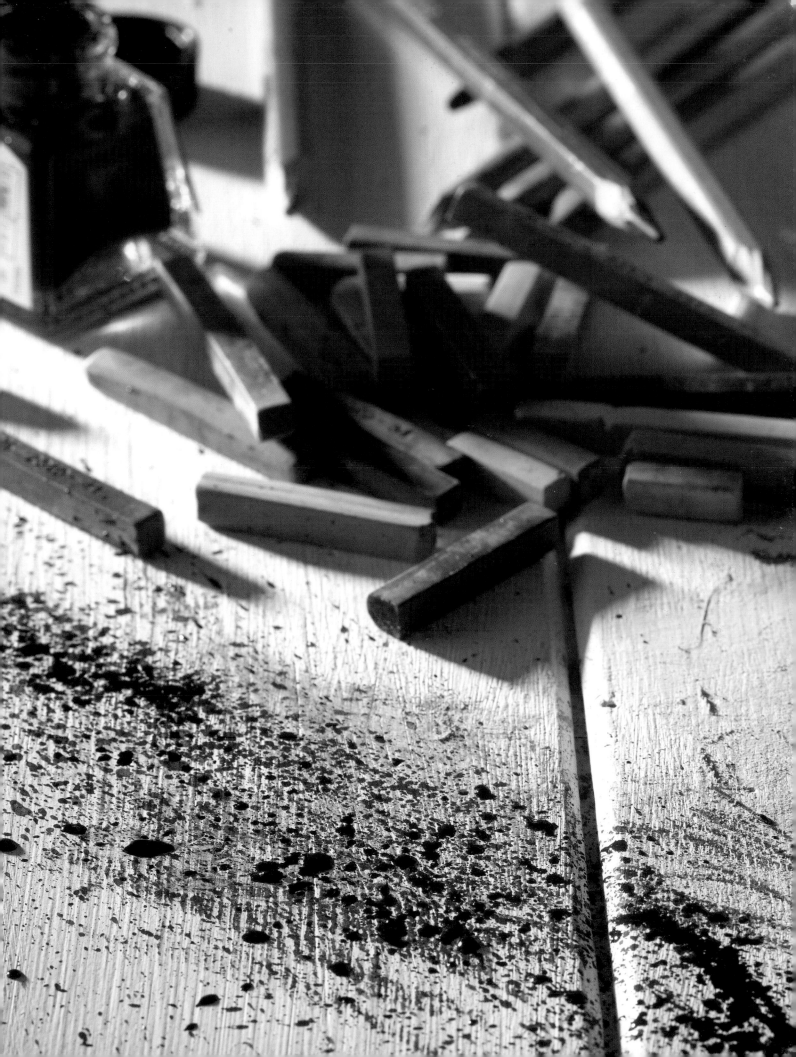

Surfaces

I like to experiment with surfaces and try out as many as I possibly can. Often I find that the surface can create almost as many variants to the finished painting as my choice of materials. I have painted on everything from tissue paper to trees and from glass to walls, but I do have four staple favourites.

Watercolour paper

Watercolour paper is available in three basic surfaces: Rough, Hot-pressed and Cold-pressed, which is also known as Not. Cold-pressed (Not) paper has a lightly textured surface, Hot-pressed is virtually smooth and Rough is – well – you can probably work that one out!

I prefer to use Rough paper, as I love the textural effects that the paper enables me to create. When working with watercolour paper, it is always better to use the heaviest available.

Mountboard

These boards are available in many colours and with textured and smooth surfaces. They are basically a heavy-duty card, the kind used by picture framers to display paintings. The great thing about this kind of board is that it is both lightweight and heavy duty. This means that I can work on the surface in a frenzy (my favourite way of working) and the board can take all I can throw at it: copious amounts of water, palette knives, collage, glue and scalpel scratchings.

This kind of board is also cheap, and if you can find a friendly local framer, sometimes free. I often use the apertures cut from the painting mounts, which are thrown away by picture framers as small offcuts. Such pieces are superb for small studies.

A note of caution: watch your fingers on the sharp bevelled edge of the boards!

Canvas

Boards are great, but over more than 76 x 76cm (30 x 30in) in size they have a tendency to buckle. This is when I turn to good old stretched canvas. Canvases can be found in an extraordinary variety of textures from heavyweight rough cotton canvas to beautiful and expensive Belgian linens. The choice is yours, though I prefer to use the cheaper, rougher varieties as the rougher weaves give me textures that the smoother canvases can not. I love a bit of texture.

You can purchase canvas on rolls ready to stretch yourself or prestretched. When buying prestretched canvases, make sure that the stretcher includes at least one centre bar. This maintains a good straight edge around the canvas and helps to create a strong, bouncy canvas surface. There is absolutely nothing worse than a floppy canvas!

Driftwood and found material

Now you're talking! Some of my favourite surfaces to work on are found surfaces, such as pieces of driftwood, old signs or packaging. As with the mark-making tools, by using found materials as surfaces, I get instant interest in the form of texture, colour and design.

A coat of gesso will help the surface to grip the paint but this is not always necessary, as the binders used in acrylic paint are often enough to bind the paint to the surface.

Longevity can be a concern when using found surfaces but common sense can guide you – using watercolour on a plastic coffee cup is doomed to failure, but using acrylic paints on driftwood will give long-lasting delight.

Top to bottom: stretched canvas, rough watercolour paper, mountboard and old wooden board (found material).

14

Other materials

Found objects I often create my work using marks made with the contents of my 'treasure box', which contains ephemera of all kinds – bits of old rope, pieces of fishermen's net, foam rubber, sticks, shells – anything that can make a mark that could help me to capture the spirit of the location gets included in my box.

The wonderful thing about mark-making without brushes is the textures and shapes that can be produced. This accidental approach need not be scary: it can lead to exciting outcomes which help the painting develop its own magic. Look around; what can you find in your home, garden or while walking down the street that can be used to stamp, flick or scrape paint on to your painting surface? Keep your eyes and mind open to what each found object can do. These small pieces of tat can help to create your own unique style.

Tat bag Oh, I love my tat bags. These are just strong, clear plastic bags that I use to collect and store found objects. Freezer bags are great because you can label them to remind you where the contents were found, you can tie the tops, and they do not have holes.

Kitchen paper This is great for mopping up mistakes and equally useful for scrunching into a loose ball to add random textures.

Glue I keep a range of glues in the studio for different applications. These include glue sticks for small areas of paper collage, spray adhesive (also known as spray mount) for large areas of collage, and superglues for materials such as shells, nets and rope.

Tissue paper Tissue paper is not absolutely necessary but I love the translucency of tissue, particularly when combined with painted surfaces. Tissue paper is able to create surprisingly subtle results as well as texture.

Craft knives I use scalpels and craft knives for scratching out details, and I use palette knives for adding drama and edges to the work.

Sponges Sponges can be used to stencil marks, create texture, apply large areas of wash or even to wipe off mistakes. From expensive art shop sponges to car washing sponges, there are many options when applying paint to your work, and each will give you a different result. Try them all to find your favourite, but ask yourself, do you really need an expensive sea sponge sourced from the Caribbean when a cheap, man-made alternative will perform just as well?

Water pot I use a two-litre decorators' paint kettle that can be inexpensively obtained from any DIY store. Smaller pots, although easier to pack and store, hold less water and therefore the contents need changing more often.

Masking tape Masking tape is useful for masking areas. It is also useful for taping your surfaces to drawing boards.

Radiator roller These are the small rollers that you find in DIY stores, made to fit behind radiators and often attached to long handles. I find them particularly useful for covering large areas quickly as well as great for creating texture.

Toothbrush Old toothbrushes (or new if you feel so inclined) are one of the best improvised tools for an artist. A little flickety-flick is a good thing and can help add magic to your work. Just remember to wash the toothbrush thoroughly before replacing it back in the bathroom, otherwise you will be found out!

Collage material Keep a box or two to collect collage material. Magazine cuttings, interesting advertising, packaging and leaflets can all come in useful on our painting adventures.

Kitchen cloth Kitchen cloth is great for smearing paint to create instant texture, as well as mopping up spilt water pots!

Heavy structure gel Acrylic mediums are available in many, many variations from matt to gloss, heavy impasto to light and from mediums with added sand to added glitter. All are great to experiment with. I use heavy structure gel regularly, because it gives great textural results.

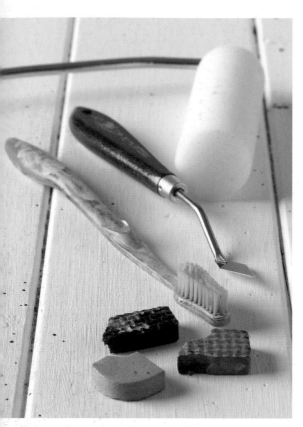

Some of my favourite tools, which allow a great variety of marks to be made. From top to bottom: a radiator roller, a palette knife, toothbrush and some small pieces of foam rubber.

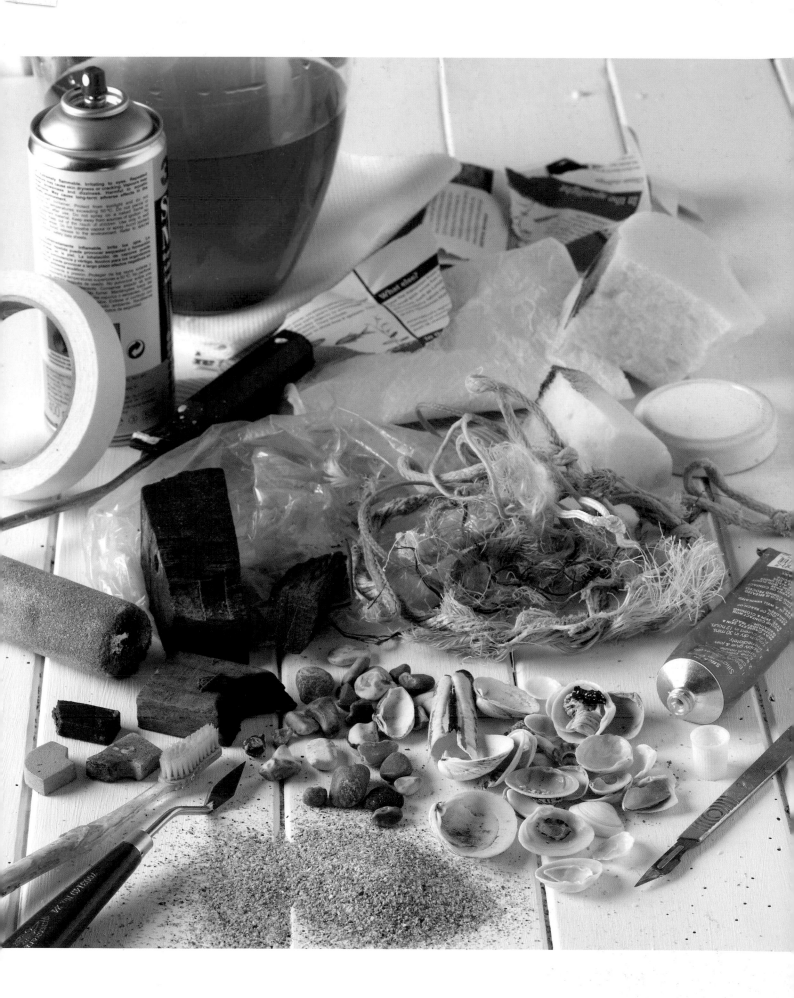

Colour

The decisions on which colours to use, how you apply colour theory and how you mix your colours are of course very subjective. The variation between different artists' choices is exactly what creates a unique palette, so experiment with colours to find your own favourite combination.

Basic palette

I regularly swap colours on my palette when I find myself becoming too familiar with mixing combinations. This helps to keep me on my toes and avoids my mixes becoming formulaic. I have a basic rule of just five colours plus white. Here is a simple starting palette.

Yellow ochre One of the most useful tinting colours you can keep on your palette, a touch of yellow ochre can tone down a bright colour in an instant.

Cadmium red medium The various cadmium colours are opaque, rich, warm and strong. I use only tiny amounts in mixes to create subtle warm hues. A good dollop of cadmium red on the end of your brush might look good enough to eat but do not be tempted... all cadmium-based paints are highly toxic.

Burnt sienna One of my favourite translucent colours, burnt sienna is literally a heated version of raw sienna clay.

Ultramarine blue I find ultramarine blue to be most useful in mixes. It adds a subtle grey-blue to all tones and helps to naturalise colours that are otherwise too bright.

Cerulean blue This is really useful for skies and shadowy areas. Because it is not the most opaque of colours, it is also great for glazing.

Titanium white This is far and away the strongest and most brilliant of the whites, but be sure to buy the best quality white that you can afford as the cheaper alternatives are simply not up to the job.

My palette, laid out with (clockwise from top) yellow ochre, cadmium red medium, burnt sienna, ultramarine blue, cerulean blue, and titanium white.

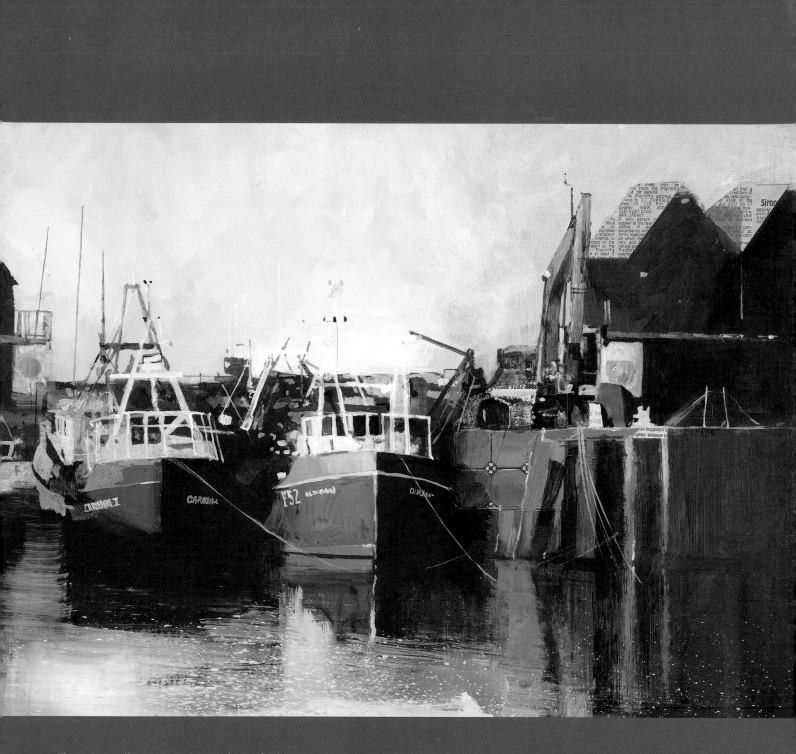

This painting illustrates my basic palette of colours in action. Cerulean blue is used for the sky and sea mixes, the darker ultramarine blue is added for work on the boats, and burnt sienna creates the wonderfully warm quayside. Yellow ochre and cadmium red are reserved for small touches to draw your eye.

Limited palette

A copy of John Collier's *A Manual of Oil Painting*, which was published in 1890, sits on the bookshelf in my studio. The author gives clear advice: 'Economy should be studiously avoided in the setting of the palette; there is nothing more likely to give a bad style in oil painting than insufficiency of colours.' In my experience nothing is further from the truth.

For me painting is a lot like cooking, and the ingredients used in a recipe become the colours on my palette. If, like me, you are not yet a Michelin starred chef, it is a whole lot easier to prepare a dish using a small selection of well-chosen ingredients instead of using the entire contents of the fridge. The same principles apply to colour. Using a small handful of colours – in my case just five – helps to give more control over colour mixing, colour balance and the final outcome. This is due to the fact that your eyes pick up the same colours used in all of your mixes and this in turn creates harmony.

Deciding on a palette

How do you decide on your own limited palette of colours? Choose a few that appeal to you but that also fit into a colour-mixing plan. This plan should include a rich blue, a vibrant red, an intense yellow, titanium white and an earth colour.

I do occasionally add a little green to my palette now and again. It helps to shake things up when I find my mixes becoming formulaic, but even then the greens are tampered with and toned down.

Tip

If you really want to know how to incorporate that hideous magenta, lime green and fluorescent yellow that winked at you in the art shop, I can not help you. Well, I can, but I won't. They add little to a limited palette – avoid them!

Newlyn Dawn

This painting was an exercise in working with a limited palette. I restricted myself to only cerulean blue, titanium white and raw umber. The cerulean blue and raw umber mixed to create my darks while combining the cerulean blue with titanium white gave me a variation of pale blues and highlights.

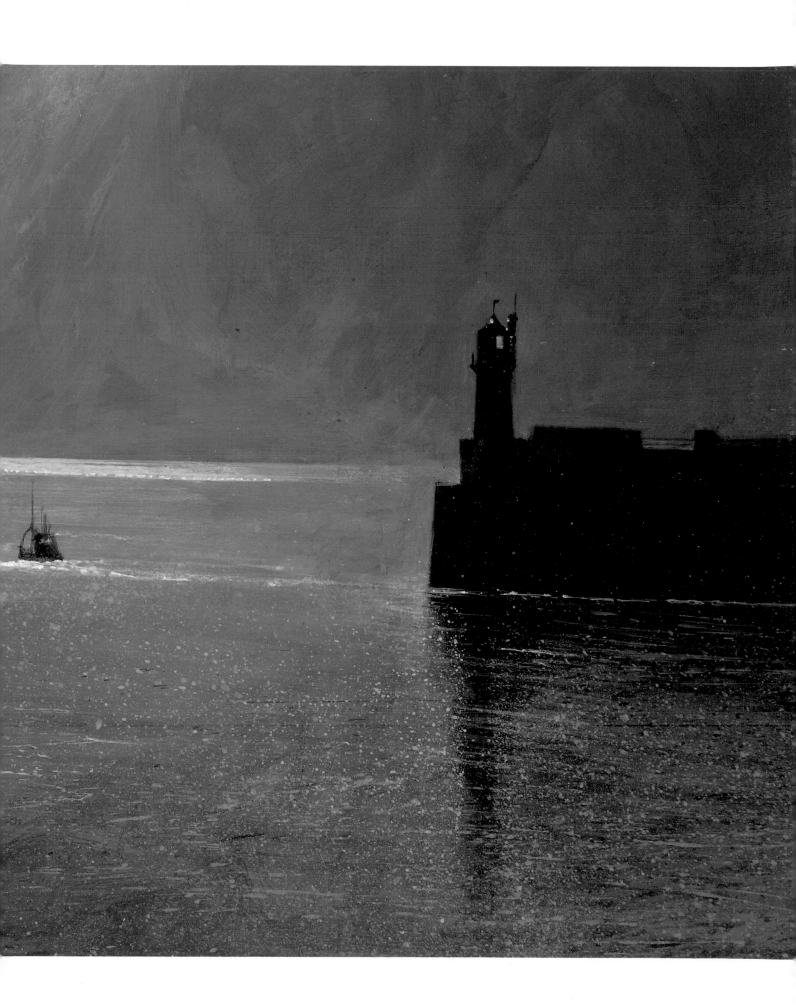

Colour mixing

Colour mixing is an incredibly individual act for all artists. Each artist has their own idiosyncratic ways to mix that perfect green or that warm shadow and these nuances are usually gained through trial and error. As preparation for this section I asked fifty of my artist friends to list their favourite three mixing colours. How many completely unique colour lists do you think I received back? That's right, fifty. No two were the same. If you sent me your list of three colours, I bet that your palette would be unique too. This unique choice of colour is exactly what helps to make an artist's work their own.

There are a few simple guidelines that can help us to avoid the muddy mistakes that so often crop up while painting. Firstly, as described on the previous page, I always recommend you use a limited palette of colours as learning mixes from just a few colours is really beneficial.

Colour mixing grids

The best way to see how your chosen colours work together is to paint a colour mixing grid on to a piece of board. To do this, simply dab a square of each colour vertically down the left side and the same horizontally across the top. By cross-referencing and mixing the colours you will create all of the basic mixes. I say basic because you can of course use the mixes to create yet more mixes, but this topic needs a whole book to itself!

With the grid completed, add white to one half of each mix to see how the colour behaves when lightened.

How to mix

An important point to remember when mixing colours is that you should always start the mix with the weakest colour, which is often the paler colour. For instance if I need to mix a blue for a Mediterranean sky, I would squeeze out titanium white on to my palette and then add touches of blue progressively, a little at a time, until the required depth of sky blue is achieved. If you mix the opposite way around – starting with the blue and adding white – you will end up with a huge quantity of paint on your palette before coming anywhere near to mixing the colour you were looking for.

Colours

I regularly replace colours in my limited palette, simply to keep my mind and my work fresh. I will often remove a particular blue and replace it with another or swap crimson for an orange. This necessitates learning new mixes from scratch and I find the process exciting. You simply can not beat mixing up a new colour that surprises, energises and excites you.

You do not really need greens if you have a well-chosen blue and yellow, and you do not need a black at all. I mix my own 'black' from ultramarine blue and burnt umber (my earth colour) and what it gives me is a rich, satisfying dark which is a lot less dominant than true black.

Muting

It pays to remember when mixing colours that it is easy to tone down a mix that is too bright simply by adding a touch – and I mean just a touch – of an earth colour, as this has the effect of 'naturalising' the colour. On the other hand, if you mix dull colours initially, it is almost impossible to brighten them.

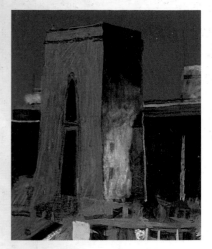

Cerulean blue was used as a base colour for these sections. Shadows were added using ultramarine blue and highlights with a mixture of ultramarine blue and titanium white.

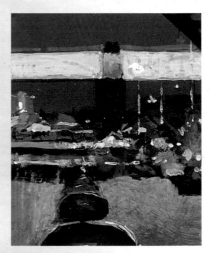

Contrasting oranges and yellows against the deep blues imply the bright lights. Working with complementary colours in this way creates vibrancy.

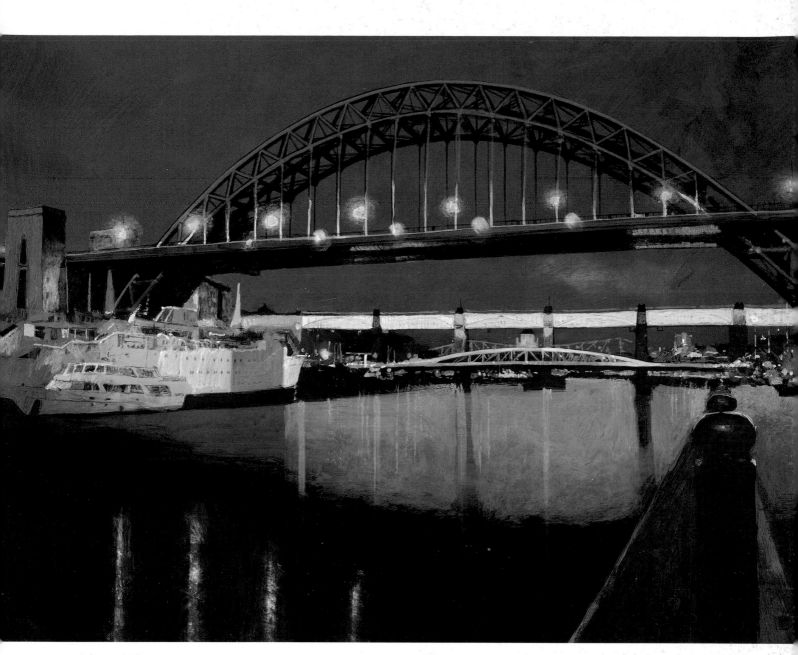

Bridge Light

You can see in this example how just a few colours mixed successfully can create a rich result. Titanium white has played an important role in the success of this painting, being used in mixes from the subtle highlights on the far left bridge, through the boats to the detailed shines on the posts on the right-hand side.

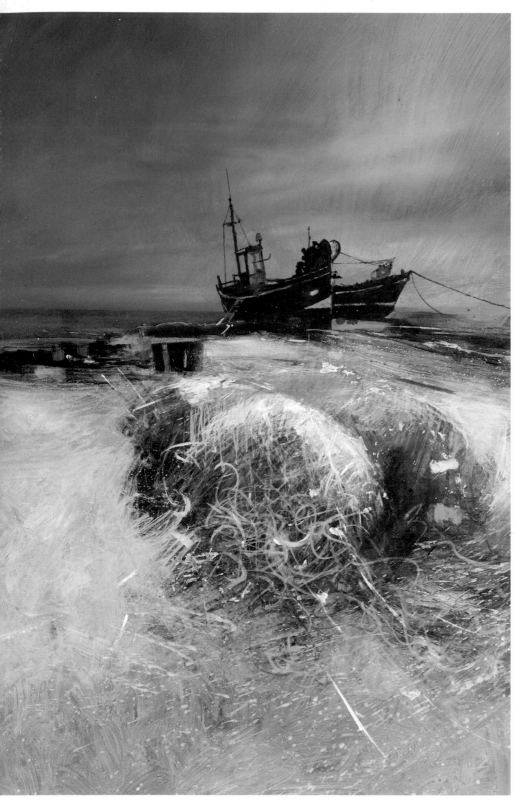

Your palette

Swapping colours will encourage you to create new colour combinations. This is an aspect of painting that I find particularly fascinating. By introducing a new little member to my paint tribe I can invigorate myself and my work by forcing myself to learn a whole bunch of new colour mixes. This simple process will help to stop your work from becoming formulaic, as this is the antithesis of expressive, sparky painting that has life and magic; and it is the life and magic in painting that you and I are about, right?

Local colour

Another plus side of working with a limited palette and swapping colours is that the very nature of having only a few colours with which to mix forces me to adapt and interpret the colours of the subject. Not wanting to represent the subject accurately might sound strange at first, but I am forced to represent the local colours in my way, using my colours, and it is very much this aspect that helps to give the paintings life.

For instance, if I look out of my studio window in late January, the fields are shades of very muted browns and grey, the trees are muted browns and grey and sky is, well, grey. On days such as these (and please do not misunderstand me, muted, subtle and grey can be beautiful too), I like to search for and accentuate the colour rather than slavishly follow the grey-brown landscape.

You can see from the two examples of the same view (left and opposite) how much of a difference is made by simply swapping out colours. The first is painted using naturalistic mixes of local colours and the second is made using a very limited palette of colours.

Beach Tat I
For this painting I used a range of six colours. The painting became slightly too 'busy' due to the colour choices.

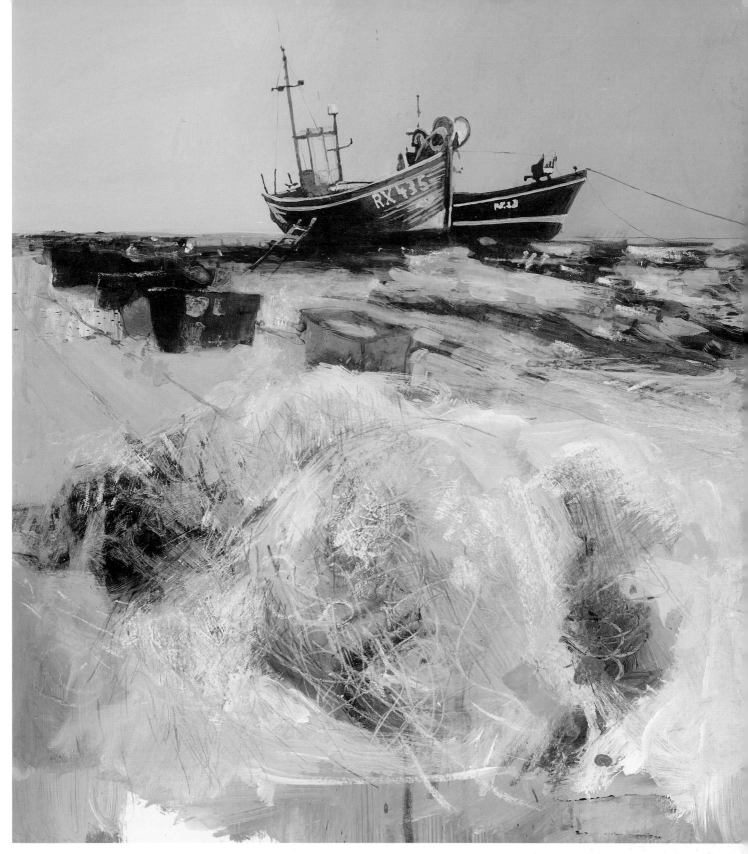

Beach Tat II

I repainted the same view and location using just four carefully chosen colours for a more unified result. Simply mixing the initial four colours makes the variation in colours in this painting. This in turn allows the viewer's eyes to pick up the colours in each mix.

Aldeburgh

Stamping is a technique that really comes into its own when working on buildings. Here it has created the structure of buildings without all of the fussy detail entailed in painting windowpanes and suchlike.

Techniques

You will love this chapter, this is where the fun starts – you get to abandon the rules and paint like a child again. The list of interesting ways to apply paint is without end and these are just a few of my favourites.

Stamping, spattering and flicking paint can add real interest to your work. Add to that the use of rags and sponges, collage and found objects and your work will never be the same again. Oh, and did I mention scumbling, glazing and scribbling? I am sure that you will find many more great ways to drip, drizzle and generally supercharge your own work.

I use all of the techniques shown here in my work regularly and recommend that you give them a go. Let's start thinking upside-down and inside-out and just see what we can find.

This detail shows how stamping helps you to create geometric shapes while allowing 'happy accidents' to occur.

Stamping

Stamping involves covering the flat surface of an object with paint before transferring the paint to the painting surface using pressure – but it is much simpler to think of it as potato printing, just without the involvement of potatoes. We all remember this way of creating art at school: cut a potato into a leaf shape, cover it in green paint and stamp yourself a tree. This is the same process, but using wood, erasers, bits of plastic, fabric, netting – anything that you can cover in paint and use to press a shape on to your artwork.

The effects that you can create depend entirely on the chosen 'stamper'. If using a solid flat surface, expect a solid flat block of colour in return. If using a piece of embossed lace, expect light patterns and twirly stuff. My current favourite material is foam as it holds its shape well and I can cut it to size easily using a craft knife. Other great items for creating stamped texture include scrunched-up newspaper, bubble wrap, corrugated cardboard and cork.

Look around you and see how many bits and bobs you can find that could give you an interesting texture or shape. Collect them in a box and label this box 'treasure box'. This treasure box will be one of your best friends in the studio.

Tip

Try stamping with heavy body acrylic medium added to your paint to create dramatic texture. These mediums are usually either white or transparent and dry to hold whatever shape you have created. Once dry the mediums can easily be painted over to create serious stamped texture.

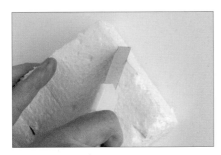

1 Cut your stamping material to shape using a craft knife or scissors – which you use will depend on the material. In this example I am using a craft knife to cut some polystyrene packaging.

2 Dip your material into paint, and use it to make some marks on the surface.

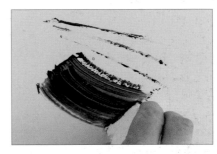

3 Experiment with the material: use different angles and pressures to produce different effects.

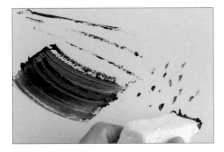

4 Some materials are better suited for details, some for broader marks. Some, like polystyrene, are good for both.

Tip

Try lots of different materials. Each will produce a different, interesting effect or texture.

Detail and control

One of the wonderful aspects of stamping is the ability to create perceived detail without fiddling about with tiny brushes. By perceived detail I mean the simple random marks that add so much to a finished composition. The viewer will read such implied detailing as figures, nets and floats, weathered walls and trees depending on your subject matter. The one weakness, if you can call it that, of stamping is not having complete, domineering control over the mark-making process as you would have when using a brush, but then that is not what this book is all about! The occurrence of unexpected blurry edges is also a real joy and can help to add depth and texture to your work.

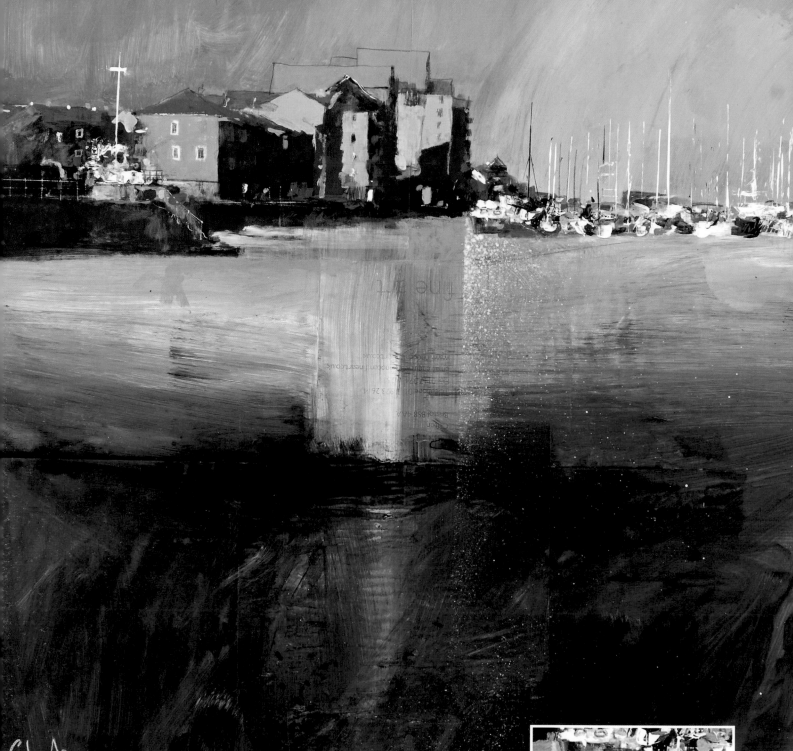

Marina Blue

Spattering and flicking paint can help to create movement in a painting. In this painting I have applied the wet paint in all manner of ways, from toothbrush flicking to spattering with small brushes.

I used the toothbrush approach to create a little highlight on the water. This also helped to change the composition by adding a much-needed vertical.

Spattering and flicking

You just can not beat a little flickety-flick now and again – those sometimes haphazard but always gratifying areas of applied paint are a real pleasure. I use a number of different applicators for this method including brushes, both large and small, my fingers and good old Mr. Toothbrush. Let us have a closer look at each one.

Small brushes

Small brushes are best used to create a beautiful line of flicked paint, as used in the wave patterns on the illustration opposite. By its very nature a small brush does not carry a lot of paint and this quality can be very useful when controlled application is important. Use a brush with long filaments as the brush hairs gather together to a sharp point tailor-made for flicking. A stubby small brush is worse than useless for this technique.

As shown to the right, the loaded brush is struck against your other hand. Think of a fly fisherman casting a rod; it is a sharp crack that we are after. This can sting a little at first but any pain will soon be forgotten when you marvel at the beautifully fluid line that you have created.

Large brushes

Large brushes are a whole different kettle of fish. The large brushes that I use are the cheap household brushes (see page 10). These do not give you much control, but they are perfect for carrying a lot of paint, and for creating very random flicked areas.

These are not the brushes to use when wishing to restrict your colour to specific areas, but rather for obliterating large areas quickly. I use these brushes and technique for adding texture.

Toothbrushes

This is probably the most controlled spattering method. By varying the viscosity of the paint and mixing with water to a single cream consistency, you can be more controlled in application. Adding more water for a milky consistency results in less control but more covering power.

After loading the toothbrush and before flicking I always perform a couple of practice flicks away from the painting. This clears the majority of the paint from the toothbrush itself, leaving me with the residue with which to work.

It is quite important to try out flicking on some scrap paper to get the hang of the technique, as otherwise you can find yourself accidentally dropping large globs of paint on to your artwork which can be incredibly annoying.

Fingers

Fingers are great for flicking paint for small areas of splatter, and they have the great advantage of spontaneity – after all, you can never leave them back at home or just out of reach!

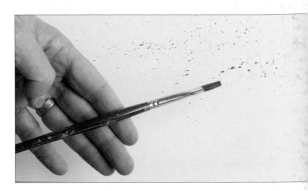

To flick paint from a small brush, load the filaments with a watery mixture before cracking the brush sharply and at an angle against the fingers on your other hand.

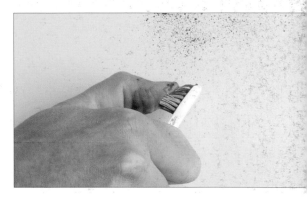

I tap the large brushes against my opposite hand as opposed to the crack of the small brushes; consequently, there is no pain involved.

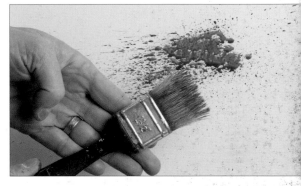

Simply dip the end of the toothbrush into your watered-down paint, then run your thumb over the bristles to spatter the paint over your chosen area.

Simply dip your forefinger into watery paint before flicking it across your thumb.

Café

Scratching out paint creates sharp highlights, which are great for adding details and scale to a painting.

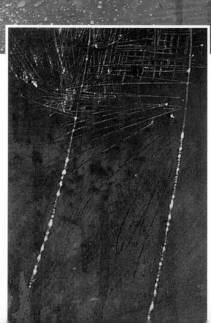

This detail shows how scraping a knife blade over the dry paint can create a 'sparkle' line. The sparkle is created when the board surface begins to appear.

30

Scratching out and using points

Sometimes I feel the need for extremely sharp detailing, very intense highlights, or both. At these times I reach for my scratching implements. I use a whole collection of sharp, pointy things – exactly the kind of stuff I keep out of reach from my children. Compass points, craft knives, scalpels and even sharpened sticks are all useful when it comes to scratching out areas.

There are two main options when scratching out paint: when the paint is still wet and when the paint is dry.

Wet effects

Scratching out wet paint can create interesting effects, often with the paint flooding back into the newly marked scratches creating useful and beautifully textured lines.

Dry detail

My favourite scratching out method, however, is to wait for the paint to dry. Once it is dry I can really go to town creating tiny, sharp moments of interest, which can be used to draw the viewer's eye to specific areas. The real strength of this technique is the ability to add incredibly sharp and tiny detailing to a fine degree that is almost impossible with any other application method.

For sharp details I prefer to use the point of a scalpel or the point of a compass, and for larger, less detailed areas I enjoy using a flat sharp surface to scrape away at the paint to create a mottled effect. For this I use craft knife blades. This is one technique where practise makes perfect, so take the time to learn how each implement works so as not to unnecessarily rip up the surface of your beautiful painting!

Surfaces

Successful scratching out techniques really depend on the surface on which you are painting. If painting on hardboard or masonite, for instance, the paint will scratch very successfully. If using heavyweight paper the technique is a little more hit-and-miss, and if painting on mount or matt board you will find that trying to scratch dry paint from the surface is nearly impossible. Of course there are all kinds of amazing illustration boards available, which are made for this kind of work, so experiment with different surfaces.

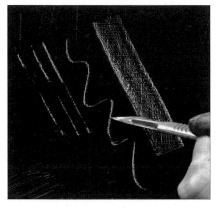

This example shows scratching out wet paint using a craft knife. Notice the different effects you can get by using different parts of the blade. Be sure to make the marks by dragging the back of the blade – do not push it or you will cut through the surface!

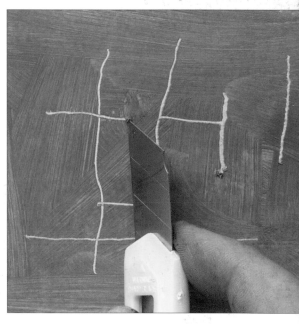

This example shows scratching out dry paint using the point of a craft knife.

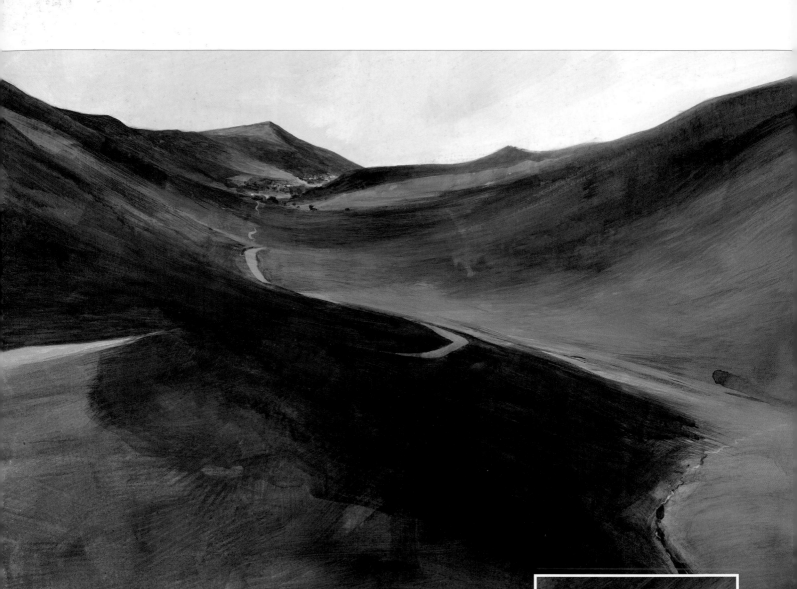

Newlands Pass

You can see from the example above how sponges and rags can create textured results quickly and easily. Loose areas of glazed colour were used, with detailed areas kept to a minimum.

Overlaying sponged and ragged areas of colour creates interest that is almost impossible to create in any other way.

Using rags and sponges

Rags, sponges, crumpled-up newspaper and other swipeable materials are all favourite little helpers of mine. In fact, I use these techniques in almost all of my work. They are particularly useful methods when you are in a bit of a reckless mood and do not mind taking risks. Spend some time to simply play with the paint, without a strong outcome in mind. This haphazard approach can become the catalyst for your best work.

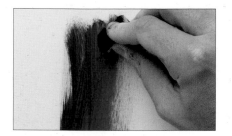

The effect achieved when wiping with a sponge is textural, with broken edges. Try using more or less paint for different effects.

Dabbing with a lightly-loaded sponge can give an effective dappled texture.

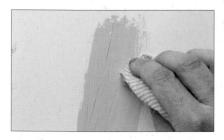

Wiping a rag loaded with paint will quickly build up coverage.

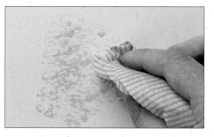

Dabbing works just as well with a rag as a sponge. Remember to load it only lightly with paint to produce the textural effect.

Techniques

Swipeable materials can be used in two basic ways; either to apply paint or to remove paint from the surface. Both techniques can provide wonderfully soft, atmospheric effects and are perfect for covering large areas quickly. Sponges and rags are absolutely perfect for adding colour and texture quickly with minimum effort, and using textured sponges or crumpled newspaper makes it easy to achieve rich depth of colour and texture in your work.

I use these techniques with abandon, particularly when wishing to paint moorland, old weathered walls, mountains and other natural surfaces. Sponges are perfect for working skies and clouds, while crumpled paper is perfect for creating foreshores, grasses and scrubland.

Try stamping paint to your surface using a textured material, and try wiping wet paint from an area using a damp sponge. Both methods will give you fantastically differing results, one smooth, one spiky.

Accuracy

Working with a rag or sponge can be a little hit and miss when it comes down to accuracy. It is therefore usually best used in the early stages of a painting to create interest on which to work. This has the added bonus of creating a single base colour, which can be useful when establishing lights and darks for your painting, rather than starting work on the dreaded blank white surface.

Tip

Clean rags and sponges can be used to remove excess paint, spread it around, or to smooth colour into the painting surface.

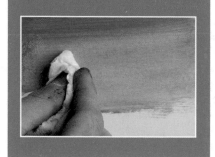

The Boat Float

Glazing colour over collage can create fantastically vivid results. Adding more collage – and more colour – can only bring joy!

You can see from this detail how the collage material is allowed to show through the paint surface. This adds an all-important layer of interest.

Overpainting and collage

I tend to get a little overexcited when talking about collage, as collage is the method of working that I find most interesting, fascinating and creative. Collage is a process of discovery, and when using this technique I am constantly re-evaluating my work, searching for the shapes and searching for the interest. In return for my hard work, the collage creates unique colour combinations, patterned shapes and text that provide interest and intrigue.

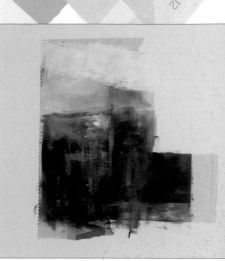

1 Spray the back of the paper (or other material) with spray adhesive and apply the first piece to the paper.

2 Attach more pieces of paper in the same way to build up a small composition.

3 Apply paint with the foam rubber, allowing some of the underlying colour of the collage to show through.

4 Continue building up and overlaying paint to enhance the effect.

Tip

If you use spray adhesive, you must varnish the piece in order to make sure it will stay in place permanently. If you use PVA, this is not necessary.

Printed collage

My own way of working with printed collage (magazines, newspapers, tickets etc.) is to layer the collage with paint. I often start with a collage base that is laid out as a very basic version of my chosen composition. Once dry I work on top with paint before adding more collage, more paint and more collage. This way of working helps me to build a richly patterned and coloured image. The layering effect also has the added bonus of creating texture and depth to the surface.

My favourite aspect of all about collage is the unexpected directions in which adding printed material to your work can take you. Suddenly a section of ripped-up advert from a magazine becomes a group of buildings, newsprint becomes a ploughed field and those sweet wrappers work perfectly as harbour clutter: exciting stuff!

What to use

Of course you sometimes need to use a little common sense when making a collage. Not all pieces will work and the subject matter needs to be taken into consideration. For this reason I always use found materials that are relevant to my painting, such as menus from a nearby restaurant, tourist leaflets or local newspaper cuttings. Using relevant found materials links the painting to its location.

Some collage materials will work better than others and some will struggle with certain adhesives. For large areas of printed paper I use a strong spray adhesive; this covers superbly without the problem of cockling, which can arise when using wet glues. For heavy papers and card I turn to PVA glues and for small collage areas I use a glue stick, which is perfect for touching in those all-important finishing details.

Tip

Remember that when you use printed type, your audience will be able to read it. I found this out at an exhibition a few years ago. Guests at the show seemed very interested in one of my paintings in particular. All seemed well, until I realised that the attraction was not the painting itself but a collaged advert from my local newspaper stating 'Ford Escort for Sale'.

Beach

Three-dimensional collage can take your creative painting to a whole new level. But remember, only add objects if they are relevant and say something about the location.

This sand is actually ground shell, which adds an amazing sparkle to the painting.

Three-dimensional collage

Three-dimensional collage demands a little more planning and a lot more glue than its two-dimensional cousin. Some artists create entire works using just three-dimensional objects but this process is a little out of the realms of this book. I tend to use three-dimensional collage as the finishing touch; adding three-dimensional collage at the end of the painting process using found ephemera such as shells, rope, stones and leaves. When using three-dimensional and heavyweight collage materials, you need both stronger adhesives and firmer, less flexible supports on which to work.

Using three-dimensional collage is a real joy; this process can really raise your painting from mundane to spectacular, simply by adding a few chosen found materials. It will add depth to your work – literally as well as artistically – and can really help to capture a moment and tell a story.

1 Use a palette knife to apply heavy structure gel, aiming to build up an interesting, broken and random texture.

2 Pour loose sand directly on to the wet heavy structure gel, then lay your surface flat.

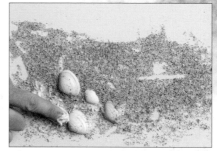

3 Drop a few shells on to the wet heavy structure gel from about 15cm (6in) above the surface, dropping a handful to get a natural fall. Use your finger to roughly smear the wet sand over the edges of the shells to help secure them.

Adhesives

Of all of the adhesives available the one that I use the most is PVA (polyvinyl acetate if you are not yet on first name terms). PVA is also often referred to as wood glue and sometimes school glue. It is a great adhesive because it is strong, rubbery, cheap and easy to obtain. Sand, soil and leaves mix easily with PVA to create texture. It can hold paper, card, board and objects such as small shells, buttons and gravel.

PVA is not really made to hold larger items such as stones or driftwood so I turn to good old superglue and other super strong sticky substances for heavyweight collage materials.

I particularly enjoy using acrylic mediums like structure gel as glue: their use means that I can create texture as well as create a firm bond between object and support.

Supports

Supports such as papers and watercolour boards will tend to buckle under the weight so are best avoided. Mountboard and mat board are usually man enough for the job except when using particularly large pieces of collage material, such as driftwood. If a painting is utilising such heavy material, I turn to a wooden support such as ply or chipboard. These types of board are firm enough to take the heaviest of collaged materials, do not buckle and can easily be painted over.

The downside of using heavy-duty boards is that they are by their nature very heavy, which can cause problems when framing and hanging. When hanging a large piece of collaged plywood from picture framing cord, you had better make sure you have banged in the nail pretty firmly!

Tip

Dropping the shells from a little way up reduces your control and gives a good spontaneous feel to their layout. You might like to think of the action like a chef salting his food!

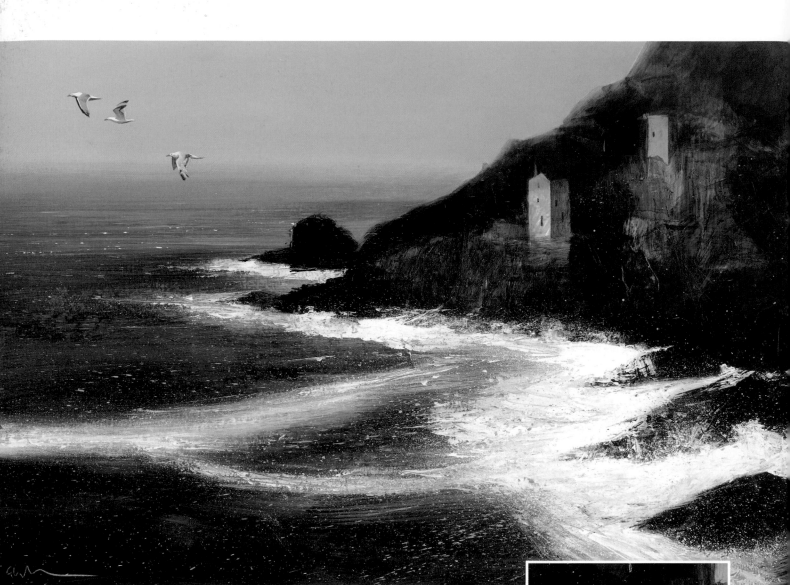

Crowns Mine

Scumbling creates an optical mix. An optical mix happens when two or more colours are overlaid to create another colour. This is particularly useful for creating implied texture and more intense colours than would usually be obtainable from physically mixed colours.

The scumbling technique allows the underlying paint to show through which in turn creates a wonderful glow of colour. Scumbling is best used for painting lights over darks but can be used successfully with darks over lights as well, as this example shows.

Scumbling

A lot of my painting techniques are small scale decorating processes that I picked up from the plethora of decorating shows that graced our television screens in the 90s. Scumbling is one of the best.

Scumbling is a technique that I use frequently to add texture and variations of colour to areas in my work. In essence, scumbling is scrubbing dry paint on to a dry surface, leaving small gaps in the overlying paint to allow some of the underlying colour to show through subtly. This creates an optical mix: a mix that your eyes create for you as opposed to a literal physical mix where the colours blend together. Artists such as Seurat used Pointillist techniques to create optical mixing, and you can also find the same effects used on poster hoardings – all those large dots of pure colour combine to create a smooth image when viewed from a distance.

1 Lay in a base colour and allow to dry. Using the paint undiluted, straight from the tube, apply it over the base colour with an old brush. Scrub the paint into the surface fairly loosely and randomly.

2 Continue scrubbing the paint into the surface until you have covered the area you want.

You can repeat the technique by simply overlaying the same consistency of paint. Try using different colours and light and dark tones for different overlaid effects.

Method

The golden rule for scumbling is to work the fresh paint on to a completely dry layer of paint. The technique involves overpainting – that is, layering one colour over another – using a dry brush and paint straight from the tube.

Scumbling is a technique that is easy to do as long as you remember to carry only a little paint on your brush. Too much paint or paint that is too liquid will create a flatter surface and a flat surface is definitely not what we are after.

Scumbling is where old, scrappy brushes really come into their own; those loose and wild brush filaments scratch the paint on the surface, creating all sorts of great spiky effects such as dry grass, weathered walls and seashore debris. Scumbling also works brilliantly with crumpled-up paper, tissue, fabric and sponges. I have also used handfuls of straw to scumble the paint surface with exciting results. Whichever implement you choose to apply the paint, be sure that the underlying surface is dry and that your paint is not too wet!

Tip

Scumbling is a technique that can easily 'kill' brushes, so be sure not to try scumbling with that beautiful handmade sable.

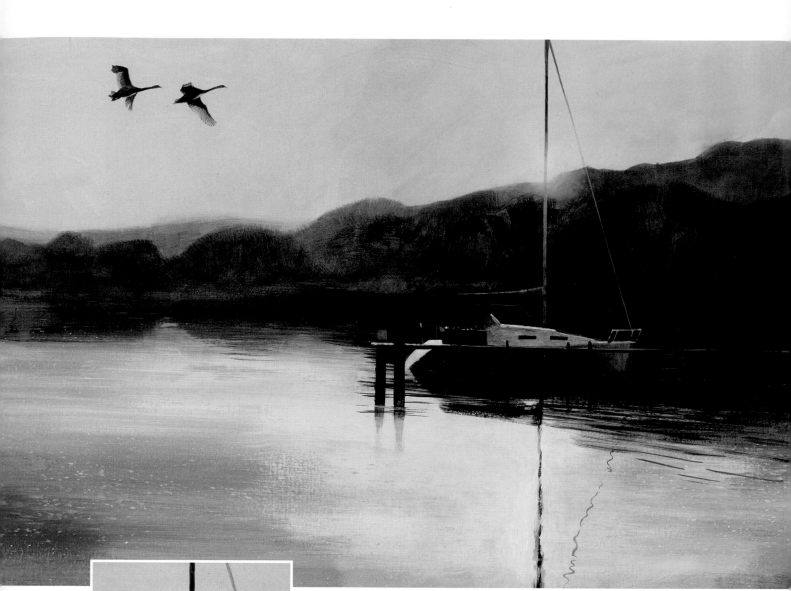

Evening Light

Glazing is similar to scumbling except that we use the paint with added water. This helps to make the paint more translucent and it is this translucency that creates the optical mix.

You can see from this detail that the glazing technique has been used not only to create the vivid orange of the hills, but also the dark foliage and bright sun.

Glazing

Here is another classic decorating technique that has found its way into fine art – or rather, the other way around! How did Turner paint those amazing sunsets? That's right, by glazing!

Glazing is great and can be used to create wonderfully glowing areas of colour. A glaze is a film of juicy, translucent colour and in its purest form, glazing is layering a translucent wash on top of another dry colour.

This technique is particularly useful when you wish to allow the underlying shapes, brushstrokes, collage or lettering to show through, or to modify a colour on your surface. Think of glazing as stained glass and you will get the idea.

When used as a glaze, white paint can knock back and lighten areas easily whilst allowing the underlying details to show through. A rich dark glaze can create shadows while keeping the underlying work visible. Try experimenting with glazes such as blues over opaque reds for amazing purples or watered-down reds over yellows for rich oranges.

As in traditional watercolour, the luminosity of glazes all comes down to the 'light bouncing off the painting surface through the glazes' scientific stuff. Glazing can be used to create much richer 'mixes' than traditional mixing. Try glazing a blue over a yellow and you will find that the green optical mix is far more intense than when mixing the same blue and yellow together on a palette.

Tip

Of course, you do not need to stop at one glaze. Find out what happens with glaze over glaze over glaze…

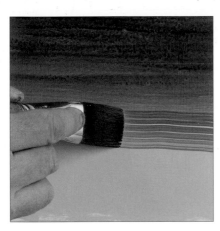

1 Lay in a base colour and allow to dry. This technique works best with a light base colour. Using paint diluted to a skimmed milk consistency, apply it over the surface using smooth strokes.

2 Continue drawing the paint over the surface, then allow to dry.

You can continue to glaze, either strengthening the colour with more of the same paint, or using a third colour. Experiment with using light and dark glazes.

Method

As with scumbling, a glaze needs to be washed on to a completely dry colour to stop the layers physically mixing. The main difference between scumbling and glazing in the case of acrylics is the use of extra water. By mixing plenty of water with your chosen acrylic colour you can create a translucent wash that can be used to alter the underlying colours.

Glazes can also be mixed using glazing mediums. These mediums are superb for allowing the creation of a translucent wash by keeping and even enhancing the viscosity of the wash. In other words, water thins the paint while glazing mediums keep a thicker consistency without making the paint opaque. A good glazing medium disperses the pigment much more evenly than water alone due to the fact that mediums are made with the same binder that acrylic paints use.

Glazes can be applied with brushes, sponges and rags; and I often rub glazes on to my painting surface using my fingers.

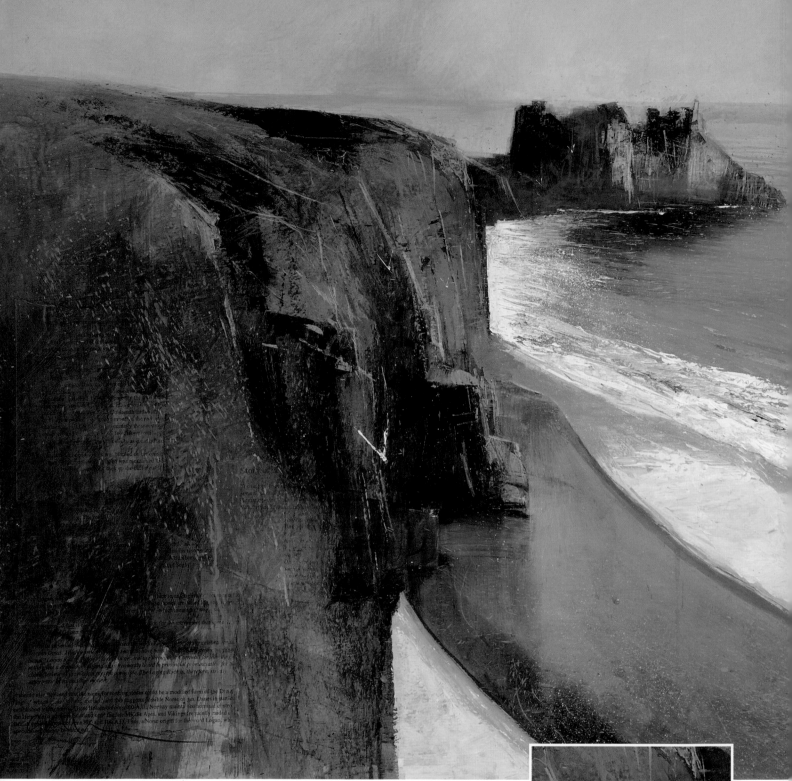

Pedn Vounder

Using pencils and pastels to scribble on your work allows unexpected jewel-like areas of colour to appear.

Try scribbling with pencils into wet paint and with pastels over dry paint.

Scribbling

Scribbling with a handful of pencils instantly takes me back to my childhood. There I am at my Nana's house, five years old, the weird 1970s wallpaper looking like a juicy blank canvas and her lipstick winking at me. 'Go on, scribble with me,' the lipstick whispered. 'No one will know...'

These pages are not about lipstick, they are all about pencils, pastels and crayons – but one person's lipstick could be another person's crayon. What I am trying to say is that when scribbling I tend to use whatever is around me, be it good quality watersoluble artists' pencils or cheap kiddie's crayons, fine pressed charcoal from the Somerset Levels or a burnt matchstick – they are all valid mark-making equipment.

Mix and match

I often scribble colour on to my work using a handful of colours at once, simply by making sure that the tips all line up. By colouring, shading and generally scribbling in this way, I am able to create randomly coloured and textured areas. This is particularly useful in adding sparkle and depth to landscapes, buildings and weathered textures.

So have a look around you and rediscover those forgotten colouring implements. Mix and match, scribble and play.

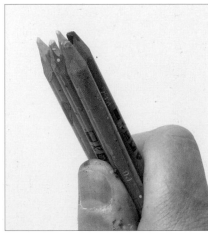

1 Grab a group of pencil crayons and hold them tightly, so the tips are all aligned as shown.

2 Simply scribble randomly over the surface, tilting your wrist to bring different tips into contact with the surface.

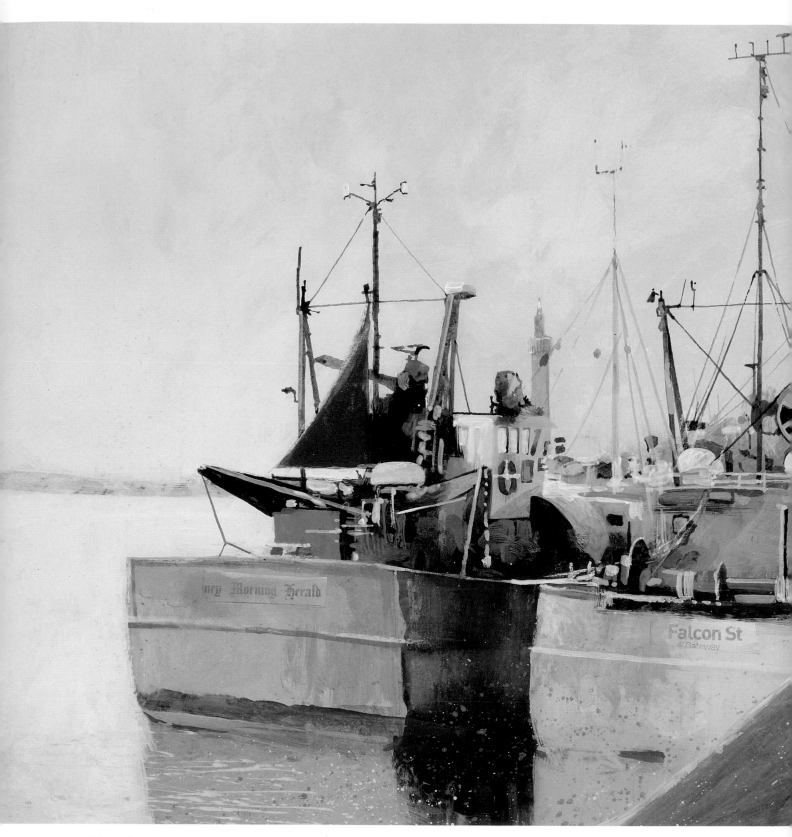

Trawlers

This picture was one of those rare occasions where I painted with a definite end in mind. I grew up in a fishing village and if I do not get the detailing right when painting fishing boats, well, I never hear the last of it...

Finishing techniques

Deciding a painting is finished is not an exact science. Sometimes (often!) it is quite difficult to decide when your artwork is complete. At times like these I usually prop my painting facing the wall for a week or two. After this cooling off period I turn it around and look afresh at my work. If the painting is complete, you will be instantly pleased and if your artwork is missing a little something, it will be obvious. This is my failsafe way to knowing that a work is going in the right direction.

For me these all-important finishing strokes and details are really what can make or break a painting, and for this reason I am very keen to use fast, expressive marks instead of overlaboured detailing.

Mood

Of course, the type of finishing stroke that you use can dictate the whole mood or feeling of the painting. For instance fast, expressive marks will create action, fluidity, alarm, movement, noise, rush and excitement. Slow and detailed mark-making will in contrast produce a feeling of calmness, quiet, tranquillity and a sense of languid peace. I use both approaches, depending on the feeling that I wish my painting to have. Landscapes often benefit from calmer mark-making methods while a cityscape usually benefits from a spikier, no-nonsense approach.

But what do I use to make those final marks? In truth, I use just about anything I have to hand.

Pastels and coloured pencils

I use pastels sometimes and soft coloured pencils often to create those all-important finishing touches. Both are great for touching in sharp flicks of intense colour.

Conté sticks

My current favourite finishing tools are Conté sticks. These are a kind of highly pigmented pastel, with a beautifully responsive touch. They are bold enough to work light over dark, firm enough to create points and details and are available in a dazzling array of mouth-watering colours.

Collage

When I am not salivating over Conté sticks I will add tiny dashes of collage as finishing touches. These tiny collage details will often be sections of type, bright colours or patterns ripped from magazines and pasted into place using PVA.

Fluid lines created with the use of soft coloured pencils.

The detail shows Conté sticks and fine brushwork lending a hand.

Collaged detailing added near the end helps to create a sense of scale.

Composition

Who is to say what a good composition is and who is to say what is bad composition? The art of composition needs a book to itself and a very large book it would be. This chapter merely aims to touch on a few points I consider crucial, and give you a few hints and tips to help with your work.

The rule of thirds

Prior to the Impressionists, artists mostly worked their compositions to tight traditional guidelines; and then along came Degas. Inspired by the emergence of photography, Degas decided to dramatically crop his paintings, cutting figures in half and using structural elements to break up the image visually. This was an exciting new approach to composition.

For those of us that are not yet on Degas' level, it is best not to throw out the rules completely. A simple compositional rule that can help us to achieve pleasing compositions each and every time is the rule, or law, of thirds. This rule makes the difference between looking at your work and being pleased and looking at your work through squinted eyes, head cocked to one side trying to work out exactly what it is about the painting that is not quite right.

The rule of thirds is one of the most commonly used compositional devices. Divide your space into three, both horizontally and vertically, to give a noughts and crosses type layout. By placing the main element of your picture in or around the top left or right section, or the bottom left or right section, the composition as a whole will work.

This guideline can also be used for creating small areas of intense movement and work contrasted with larger areas of suggested space. I am fascinated by this idea and explore this concept again and again. By focussing attention on one spot, the viewer will visually make up the rest of the area, as seen in *The Harbour Gaps* shown to the right.

This rule is also often used with sea and landscapes, the artist choosing to place horizon lines roughly one third or two thirds down the page – rarely do you find a successful seascape with the horizon in the centre.

Templates

When planning a composition I often make several quick drawings to find the layout that works best or I will cut up paper templates to use as 'placements' for the main elements of the painting. These templates can then easily be moved around the picture until an exciting balance is found.

The Harbour Gaps

The dramatic composition in this painting is simply based on the rule of thirds: i.e. the cottages and quayside detailing are one third down my surface and there is a bright highlight two thirds across, forming an off-centre cross shape.

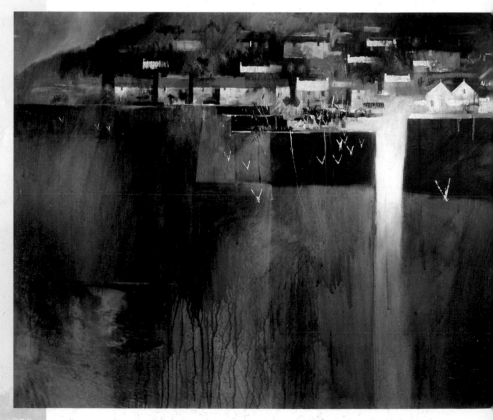

Movement and life

To create movement and life in a painting, it is necessary to have movement and life in the artist. By that I mean that if you just are not in the mood or are feeling a little lazy then that will show in your paintings. Conversely, if you are feeling energetic and full of pent-up enthusiasm, your work will sparkle with life. That begs the question: How do you fire yourself up when you are feeling lazy? I find there is one way that works every time – guaranteed. That method is to get up and do some exercise.

Don't groan! A little light exercise will help perk you up and get you excited to paint, even if you only go for a short walk. The extra oxygen taken in while exercising – or even breathing deeply – will help to energise your body. I often play music way too loud and dance around my studio, singing at the top of my voice with my brushes in hand. Anything that gets your blood pumping and adrenaline running will fill your painting with life.

These small actions will start a process of joyous, spontaneous mark-making, and joyous, spontaneous mark-making leads to movement and spontaneity in your paintings. Stand up instead of sitting down, sing and dance your brushes across your canvas.

Harbour Blue

The movement in this painting is created by adding dot and dash figures at arm's length. I was also standing (well, dancing!) at the time.

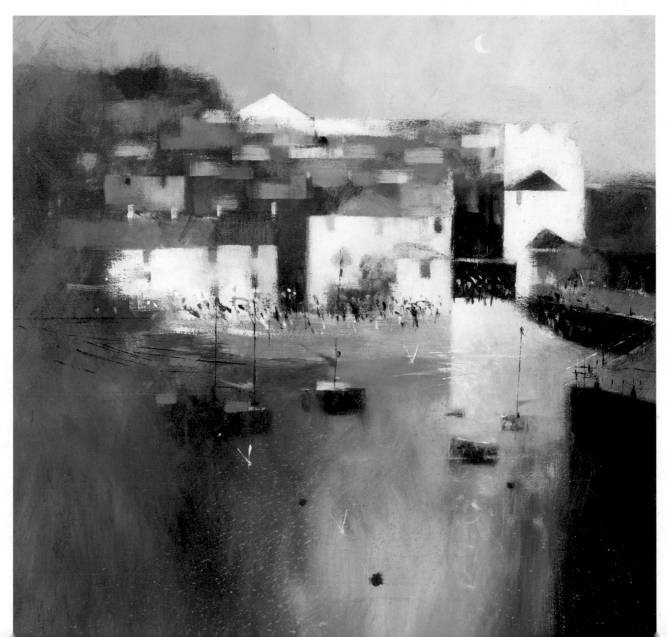

Getting started

Now this is where we pull it all together. This is where all of the elements and techniques begin to gel, this is the most interesting stuff...

 This chapter will take you through my process of creating a painting, from visiting the location with my tat bag to adding the finishing touches.

Go to the location

It is so important to at least visit your chosen location, and if possible, to draw, make notes, paint and collect stuff while you are there. By keeping your senses open, listening to the local birdsong, breathing in the scents and feeling the warm sun or cold rain on your skin, you will give an unrivalled 'authenticity' to your work. Here's the thing – the casual viewer of your painting may not realise this authentic aspect but you will know it is there, and this is important.

 A painting created by an artist who has been to the location will be more authentic than one copied slavishly from a photograph, as the little notes of local colour and touches of direct experience will help guide you in getting the specific feel of the place across to the viewer, or provide a unique insight into the area, in a way that is impossible from a photograph.

 That is not to say that photography is a bad thing, indeed some of the step by step examples in this book (see pages 58–143) needed to be worked up from drawings and photographs (I could not convince my editor to move the photography studio to the top of a mountain in Canada) and photographs can provide information that is really difficult to capture in any other way. That said, going to the location will take your ability to capture and absorb local information to a whole new level, and help to improve your painting.

Keep your senses open

Capturing the location is about more than simply pointing a camera. These tips below should help you start to capture the particular atmosphere of a place and find its essence. Once captured, we are ready to start work...

Listening Overheard conversations, birdsong, waves crashing, water lapping, wind, children laughing, dogs barking, thunder, silence. Write it all down, record the sounds if you get the chance.

Feeling How rough is that wall, the bark on the tree or the peeling paintwork on the café sign? How cold are the steel railings, the sea, and the ice? How soft is the grass, the sand, and the fallen leaves? Write it all down.

Taste Wild herbs, spring water, rainwater, lunch, hotdogs, ice cream, bag of sweets. Write it all down and collect if possible.

Scent Can you describe the fragrance of the flowers? The sea in all of its moods, the ozone and salt air? What about the city streets? The park? The cinema?

Collecting Collect as much material as you can from your chosen location, sand, stones, leaves, tickets, packaging. It is all valid collage material. Carry a tat bag with you at all times. If I have been collecting from the beach, all I need to do is to open my bag and breathe in the fragrance of sand, seaweed and shells to magically transport me back to the location. The same happens with woodland leaf litter, city finds and any interesting bits and pieces from other places that I find myself in.

Collect information in as many ways as possible – drawings, written notes, recorded sound and a tat bag full of rubbish...

Drawing and sketching

Drawing is a fundamental process. The artist Keith Haring knew this, 'Drawing is still basically the same as it has been since prehistoric times. It brings together man and the world. It lives through magic.'

Drawing and sketching are really not about getting every little detail of every little window in every building accurately portrayed. That is what we have cameras for. Drawing in its basic form is simply about getting the bones of your subject on to paper, and those 'bones' can be as simple or as complex as you like. My own drawings range from technically observed studies to meandering lines, which only really mean something to me. Often I find that the simplest drawings of my first impressions are the ones that capture and hold the magic. Transferring that magic into the finished work is where the difficulty lies. Have a look at the Masters: the loose genius of Constable's drawings and the extraordinarily fluid lines of Picasso and Brett Whiteley.

Drawing really need not be the scary occupation of just a few gifted artists. All small children draw – all of the time, it seems – it is like a compulsion. I wonder why so few adults draw? The act of drawing is something that everyone can do, regardless of ability.

The next few pages show how I go about creating a painting: starting with my first sketches of an area, developing them into colour studies and small paintings on the spot, and producing a finished piece in the comfort of my studio.

Sketches of atmosphere

Imagine – we are at our chosen location. As I write I'm in Collioure in the southwest of France, which gives me an abundance of inspiring vistas, but I could equally well be in New York, Tokyo, Sydney or in the middle of a field, halfway up a mountain or filling my car with fuel at a petrol station. I could even be in my kitchen on a rainy Saturday afternoon watching tennis on television.

Look around you and find an implement with which to make a mark and a surface on which to make it. If I have traveled with the intention of drawing then I will have a pad of paper, a pot of ink, a pen or sharpened stick and maybe a pencil. If I am in a pub in England, maybe a borrowed biro and a beer mat. Anything that can make a mark is perfectly valid.

For the Collioure sketches shown on these pages, I roamed around the town and countryside drawing, observing, collecting and looking for the views that captured the unique atmosphere of the area. I quickly filled my sketchpad with drawings and notes. I filled my tat bag with ephemera, and listened for the birdsong, chatter of sunburned tourists and whispering breeze. These elements were all noted down in my drawing pad. The location is irrelevant, you just need to experience wherever you are.

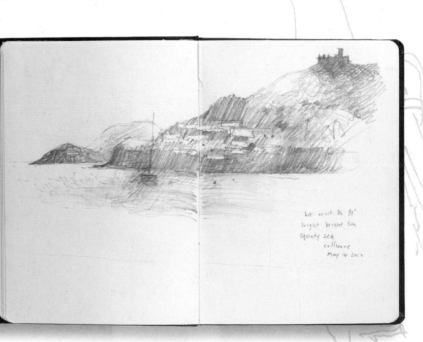

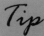

Tip

Quick drawings capture shapes, written notes capture atmosphere. Both together lets us capture the essence.

Colour drawings and location studies

With my initial pen or pencil sketches in place, I begin to look for a scene to paint. I am after exactly the same information as I am with a pen or pencil only this time with added colour – the small studies on this page are my 'colour drawings'. They are quick pictures, usually taking just ten minutes, but they are enough to get the bones of the composition down, enough to work out tones and enough to know if the view will work as a large painting.

A study such as *Old Town* (facing page, top left) is also drawn, only this time it is drawn with a brush and utramarine blue acrylic paints. The location studies on the facing page have had more time spent on them than the colour drawings below. This is either due to the complexity of the view, as in *Sardines 'n' Sangria* (facing page, top right) or simply because I get caught up in the view, the painting, the atmosphere and I simply cannot drag myself away. Note the use of collage in *Sardines 'n' Sangria*… it's always useful to have a glue stick at the ready!

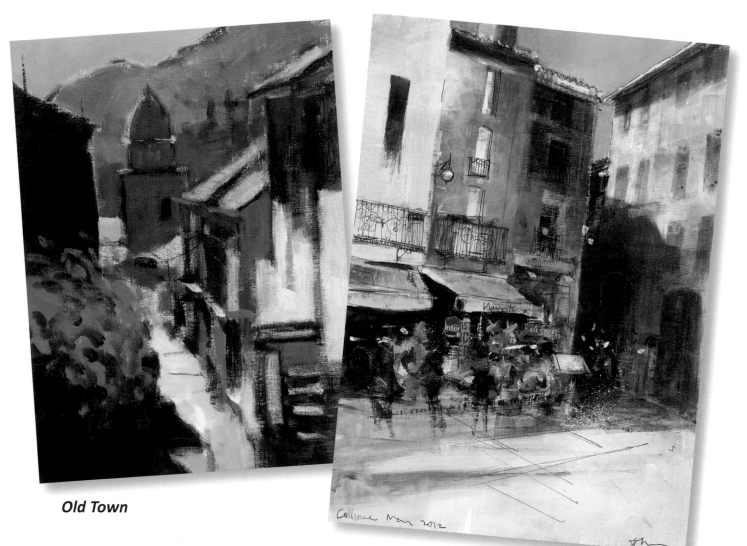

Old Town

Sardines 'n' Sangria

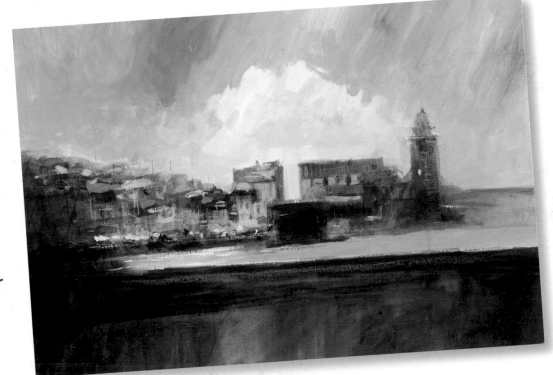

Sunlit Harbour

53

Making a small painting

Once I have explored the location area and collected as much information as possible, I begin to make on-the-spot paintings. These are often quick studies, but are equally likely to be more finished in approach, depending on my mood. I find that these are also the paintings that best capture the spark and the magic – the essence of the scene that is sometimes difficult to replicate in versions painted in my studio.

At Collioure I chose to paint my finished piece from amongst the vineyards, high above the town. While exploring and gathering my initial sketches for atmosphere, this viewpoint said the most about the location to me. The vista included the Mediterranean blue sea, the orange rooftops, the vines and the olive trees. I could also listen to the birdsong and use the spring water trickling down the stepped mountainside. All in all, this little patch of dusty, beautiful mountainside best summed up my personal Collioure experience.

I was searching for the best composition, the composition that would lead the eye to the distant town, and painted two pictures from different viewpoints to decide which would work best for my finished painting. I quickly set up my easel and squeezed out my paints, in this case, phthalo green, cadmium yellow, cadmium orange, burnt umber and cerulean blue and got to work. I was able to mix earth from the vineyards with my paint, and after searching, found a small piece of newsprint litter that was perfect for impromptu collage on the distant buildings.

The yellow foreground and sweeping lines of the painting opposite, *Melting in the Heat* certainly led my eye to the town but something did not quite work. I realised that the orange rooftops were struggling against the bright yellow foreground and therefore lost the attention. In *Cerulean Collioure*, the painting on this page, the more obvious V-shaped composition with the darker foreground tree acted as a full stop and became too dominant.

In the end, I liked elements of both so chose a cheeky combination for the studio painting (overleaf). Taking the sweeping line option of *Melting in the Heat*, I replaced the bright yellow touches with the more dusty, dusky hues of *Cerulean Collioure*.

The lesson to learn is that wherever you are painting, be it beach, park or city, try painting several versions of your chosen location to explore the possibilities.

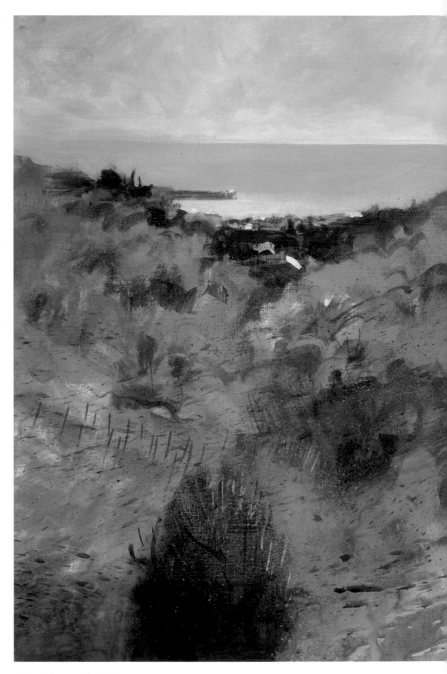

Cerulean Collioure

This location painting worked best for colour, letting the distant orange town glow. However, I felt that the foreground tree was just too dominant and held the eye.

Opposite:

Melting in the Heat

This painting had a better sweeping vista drawing the eye towards Collioure and the harbour wall. However, the yellow foreground was a little too bright for my liking.

54

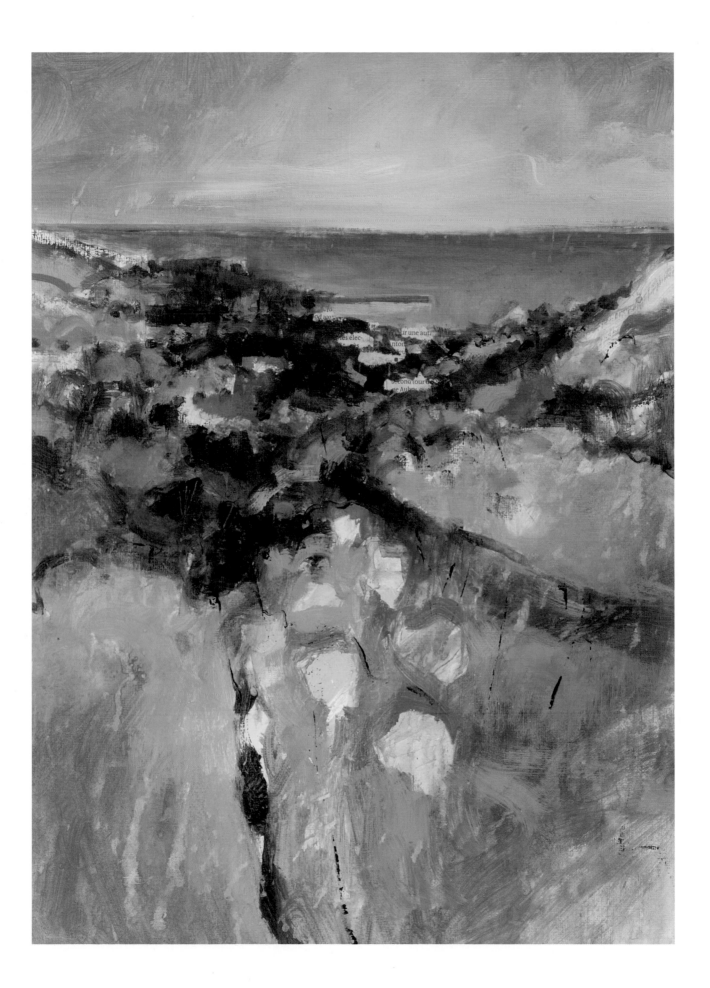

The final painting

My final painting of Collioure is shown to the left. It is a development and an amalgamation of the two studies on pages 54 and 55, mixed with a few ideas from my sketchbook drawings from earlier. Once the initial brushwork was completed, I developed the painting with a few toothbrush flickety-flicks, a little foam rubber stamping, glazed and scumbled paint, some roller work, sponged textures and Conté finishing touches – and it even picked up a bit of collage along the way.

I squared up the composition to emphasise the wide expanse of the vineyard itself and added a few extra orange rooftops to carry the town down into the dusty fields. This helps to blend in the otherwise hard horizontal lines and accentuates the sweeping nature of the landscape, which is what draws your eye into the painting.

Cypress trees were knocked in with the side of a dark green Conté crayon to provide a few verticals. The vineyard fence posts were added for the same reason using the edge of a piece of card loaded with a little acrylic. These verticals are used in a subtle way to dart your eye around the image and to create a sense of repetition and scale.

The rich, warm colours are bounced from the town at the top of the painting to the collaged elements at the bottom. The reds and yellows are further accentuated by a judicious use of various greens that have the effect of supercharging the oranges and reds; good old complementary colours and all that malarkey!

Collioure

See how many techniques you can find in this painting that have been described throughout the book. You will be surprised at how few have been used and also how easily the image can be put together using these simple techniques.

What initially looks like a complex image turns out to be a simple composition, painted with a very limited palette using a few very simple techniques.

Step-by-step projects

Right, that's enough about me. The rest of this book is all about YOU! Pull on an old t-shirt, switch off the phone and let's get messy.

The following nine demonstration paintings have been chosen to cover a range of subjects from majestic mountains to sparkling cities, from quaint fishing harbours to flower fields and from warm sunlit towns to a deep dark sea. Each painting uses a combination of the techniques explained throughout this book together with a limited palette of colours.

Each painting has a comprehensive materials list including the brushes and colours to use should you wish to copy the painting exactly. Copying the paintings is a good way to practise the techniques but what I would really love for you to do is to find your own subjects and use the examples as inspiration.

The demonstrations are designed to be easy to follow, but if you get stuck then experiment, free wheel, and make it up! After all, we are here to have fun with the creative process and experimenting is at the heart of creative fun. So, with your paint squeezed out and brushes at the ready, put some music on (a little too loudly) and let's go for it!

Tip
Be sure to email me at www.glynmacey.com with your results, I would LOVE to see them!

Corbière
A sponged sky, a flicked sea and a little dark foreground brushwork is enough to help the bright areas sing. Once you have tried all of the demonstration paintings, why not use the skills you have built up to have a try at this one?

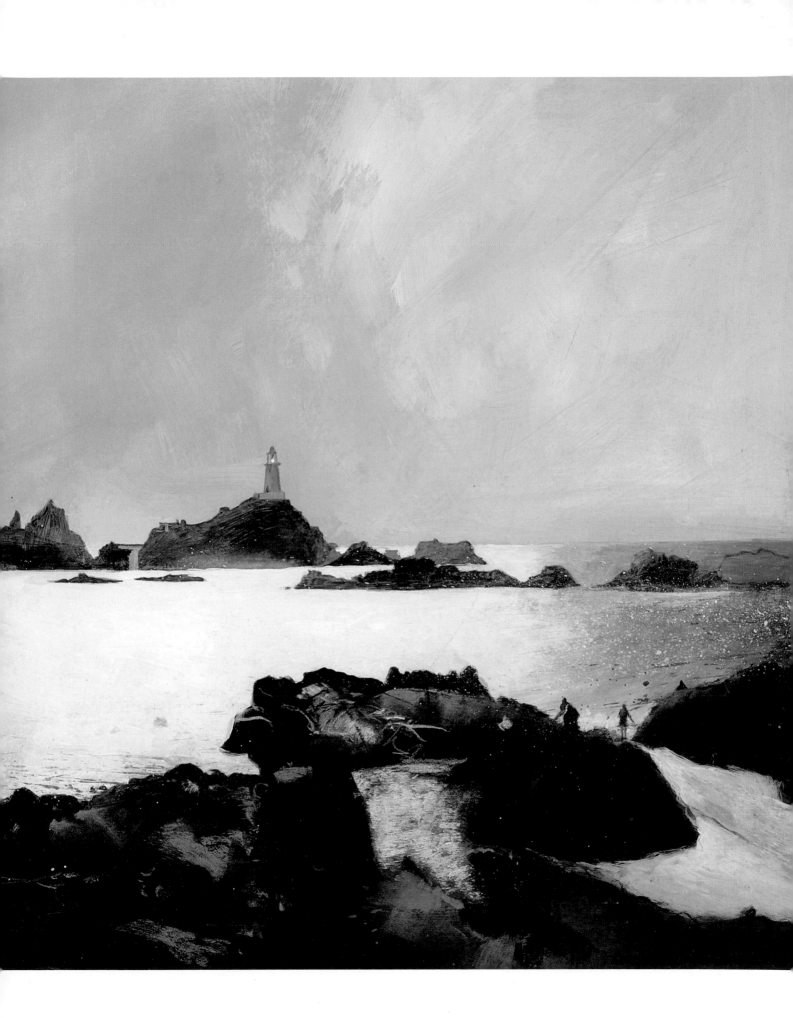

Secret Beach

The beach that I am using for this demonstration is one that I know well: Porthcurno in West Cornwall, England. This small, hidden cove of crushed shell, crashing waves, rock pools and secret caves is an inspiring location for anything creative – then again, isn't every beach?

My chosen composition focuses on the foreground waves and cliffs, and I add depth to the image using the distant headland of Pedn Vounder. By using Porthcurno sand and shells, I capture a little of the beach magic, the sense of ozone and the smell of the salt air. The colours are supercharged by creating rich hues from the underlying initial yellows and the silhouetted darks and bright highlights add drama.

Now remember, this is our beach, yours and mine, so let's keep it our secret!

You will need

Rough watercolour paper: 76 x 56cm (30 x 22in)

Paints: cadmium yellow medium, cadmium red medium, burnt sienna, Winsor blue (green shade), titanium white

Brushes: 37mm (1½in) household brush, 50mm (2in) household brush, size 28 short flat/bright, size 2 round, size 8 short flat/bright, 25mm (1in) round varnishing brush

Conté sticks: raw sienna, light brown, dark brown

Found objects: sand and small shells

4B pencil

Palette knife and heavy structure gel

Piece of sponge

Radiator roller

Toothbrush

Craft knife

Painting board and easel

Masking tape

Kitchen paper

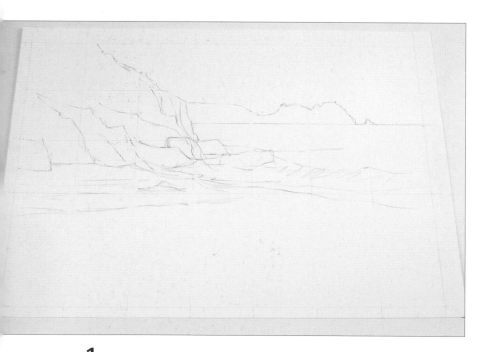

1 Lay the paper flat on your surface, and transfer your sketch to the watercolour paper using a 4B pencil. Aim to simply suggest the main shapes, rather than getting too involved with creating a perfect copy of the photograph.

2 Use a palette knife to apply heavy structure gel to the central area of the foreground. Imagine you are buttering your toast, and use long, wavering, horizontal strokes to suggest the plane of the beach.

3 Smooth the gel a little towards the midground using your fingers.

4 At the front of the foreground, create a choppier texture in the gel with the edge and point of the knife.

5 Pick up a handful of sand and drop it loosely over the central beach area from 30cm (11¾in) or so above the surface so that it sticks to some of the heavy structure gel.

6 Repeat two or three times to cover the area, then smooth it in gently by dabbing it very lightly with your hand. Pick up the paper and gently shake off the excess sand.

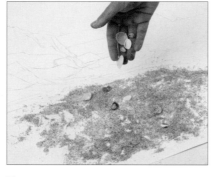

7 Repeat the process with half-a-dozen or so small shells, aiming to let them fall into a random pattern in the midground.

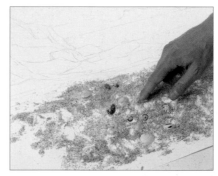

8 Gently press the shells in where they fall, applying a little more texture gel with your fingers to help secure them if necessary. Feel free to rearrange some of the shells if you like. Allow the surface to dry completely before continuing.

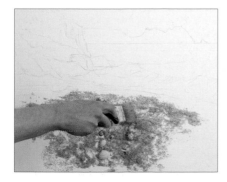

9 Secure the painting flat to a board using masking tape, and place it upright on the easel. Brush over the sand with a 37mm (1½in) household brush to dislodge any that is loose. Use firm, but not too strong, movements.

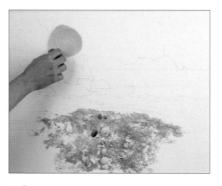

10 Pick up cadmium yellow and a little cadmium red on a sponge and use it to establish a light source on the top left.

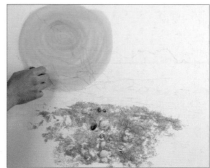

11 Spiral outwards from the light source, using the paint on the sponge to expand the light area.

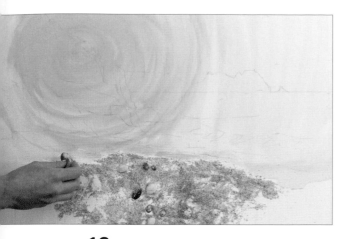

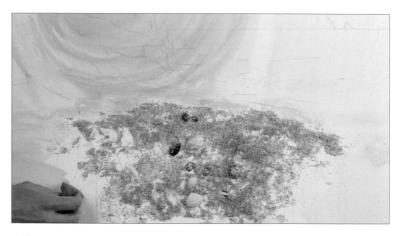

12 Pick up a little water on the sponge and extend the light area down to the beach.

13 Wet the sponge, reload it with cadmium yellow and work over the top of the sand, allowing the paint to drip down, then sponge cadmium yellow over the beach areas on the left and right.

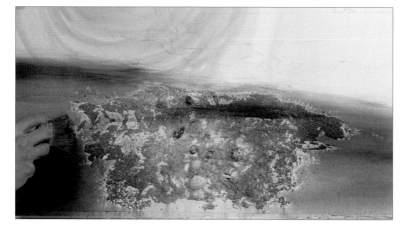

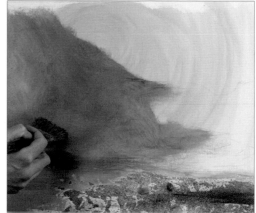

14 Apply dilute burnt sienna over the beach using a 50mm (2in) household brush.

15 Scumble burnt sienna over the rocks on the left-hand side using the same brush.

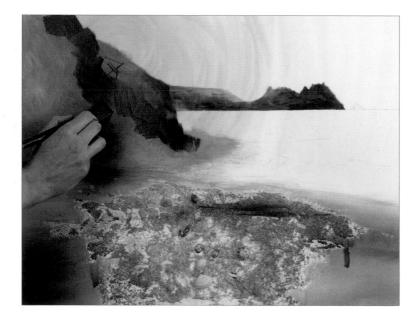

16 Use the size 28 short flat/bright to overlay the headland in the background with undiluted burnt sienna, then do the same with the midground rocks. Use the edge of the brush to achieve sharp lines and start to develop details.

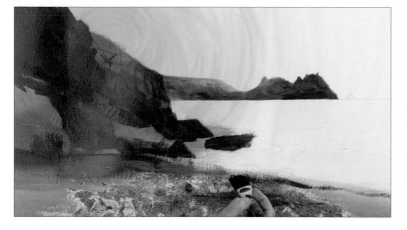

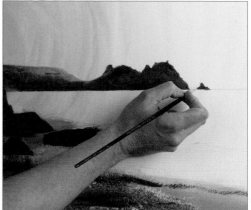

17 Continue to build up the midground rocks with short, bold, earthy strokes, then advance into the foreground, using up the last of the burnt sienna on the brush by drawing it along the waterline from the left.

18 Add detail to the headland on the right with a size 2 round and burnt sienna, and use the same to pick out the most distant rock.

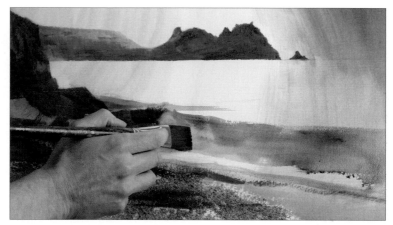

19 Switch to the size 28 short flat/bright and glaze dilute burnt sienna over the right-hand side, allowing the paint to run out as you work towards the centre.

20 Bring some colour into the foreground sea using horizontal streaks of the brush and dilute Winsor blue (green shade).

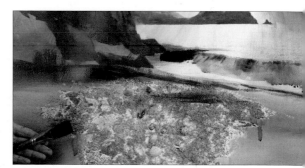

21 Spatter the midground sea with the paint remaining on the brush.

22 Make a dark mix of Winsor blue (green shade) and burnt sienna, then use the edge of the size 28 short flat/bright to create shadows on the breakers as shown.

23 Still using the same brush and mix, add the shadow of the rocks to the beach on the left, then spatter the paint over the foreground beach.

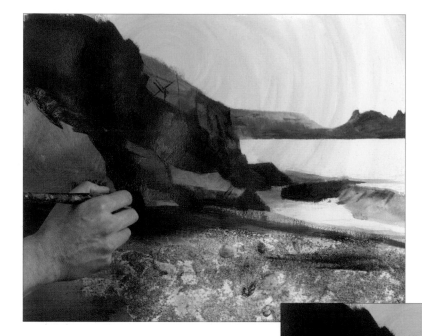

24 Use the size 28 short flat/bright with the dark mix of Winsor blue (green shade) and burnt sienna to block in the darkest shadows on the rocks, using the edge of the brush to create sharper areas.

25 Glaze burnt sienna over the foreground and midground for the midtone areas, then use the dark mix to develop the details.

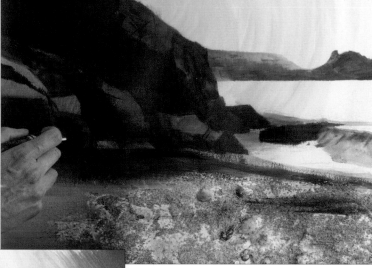

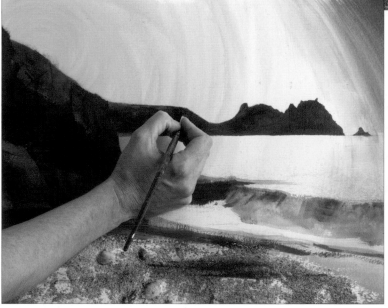

26 Switch to the size 8 short flat/bright brush and develop the darks on the headland. Make the end of the headland the darkest, and gradually lighten the mix by adding more sienna to create a gradient as you work to the left.

27 Strengthen the shadows on the right-hand edge of the foreground rocks to increase the contrast. Re-evaluate the shadows as you work, and add touches of the dark mix of Winsor blue (green shade) and burnt sienna for interest.

28 Use a 25mm (1in) round varnishing brush to add titanium white across the sea. Apply it undiluted, then pick up a little water on the brush and blend it out to the sides in horizontal strokes.

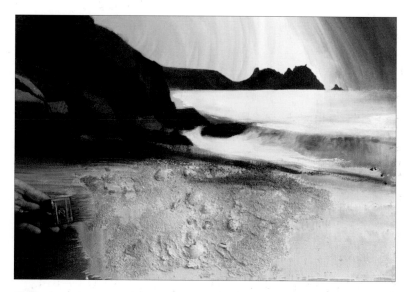

29 Glaze titanium white down to just above the breaker, and then use the paint remaining on the brush to bring the colour up in sweeping strokes along the front of the breaker.

30 Swap to the 50mm (2in) household brush to glaze dilute titanium white over the beach, leaving the left-hand edge unglazed, then spatter the foreground in the same place.

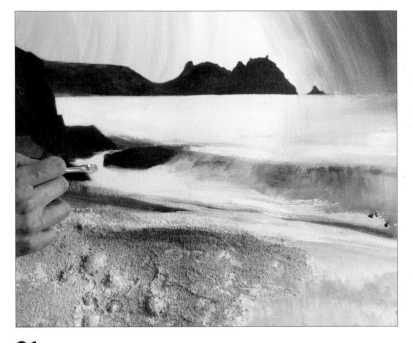

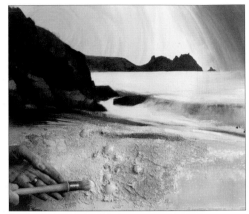

31 Use the size 8 short flat/bright to apply some strokes of titanium white at the top of the beach, and along the edge of the rocks.

32 Reglaze areas of the beach with dilute titanium white and the 25mm (1in) round varnishing brush, then spatter any remaining paint on to the same area.

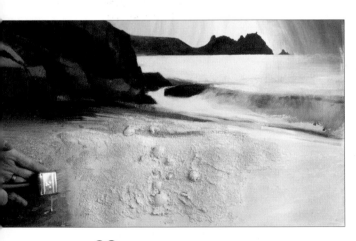

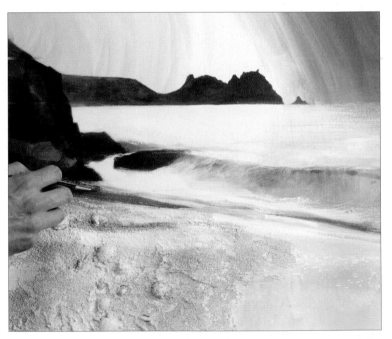

33 Use the 50mm (2in) brush to lay in dilute titanium white across the sandy area and right-hand side of the beach, then use any left on the brush to spatter the left-hand side.

34 Use a size 2 round brush to detail the breaker and foreshore with titanium white.

35 Reglaze the beach with dilute titanium white and the roller. Use the edge with any remaining paint to add some light spray above the breaker.

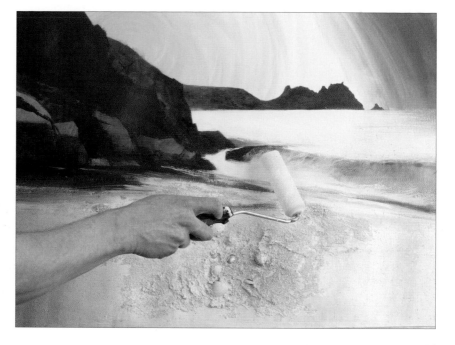

36 Turn the board upside-down and glaze the sky with the roller and dilute titanium white. Start near the foreground rocks, using the edge of the roller to ensure a sharp edge remains on the rocks. Work all the way across, using less pressure as you work to the darker part of the sky.

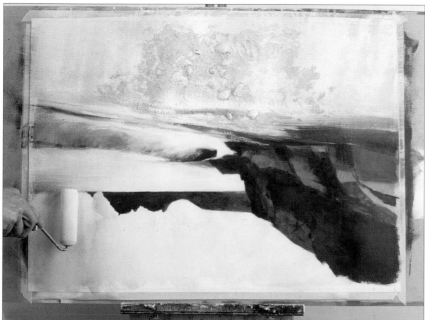

Tip

Do not panic if you accidentally go over a little of the headland with the roller; simply use a size 2 round brush to re-establish the dark mix.

37 Turn the board the right way up and lift out a little of the white on the top right using a damp piece of kitchen paper.

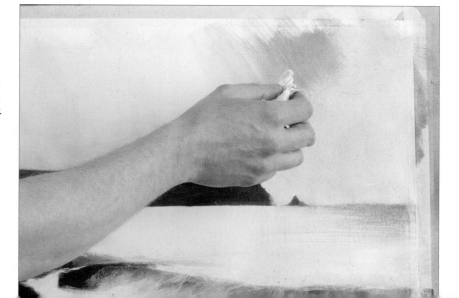

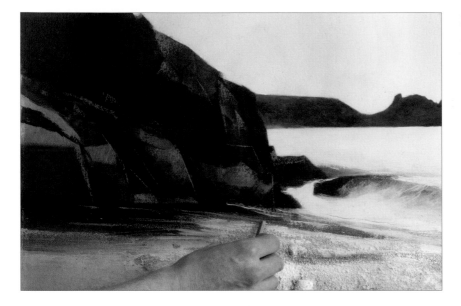

38 Use a raw sienna coloured Conté stick to develop the foreground rocks, dragging the body of the stick across to pick up the texture of the paper and using the tip of the stick to add stark highlighting lines.

39 Make a few strokes across the beach with light and dark brown Conté sticks, then spatter titanium white over the foreshore and breaker with your toothbrush.

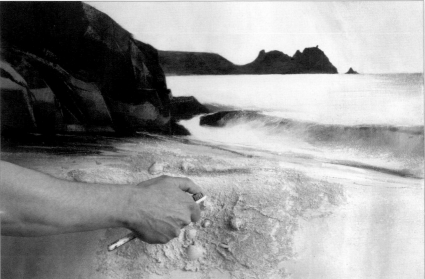

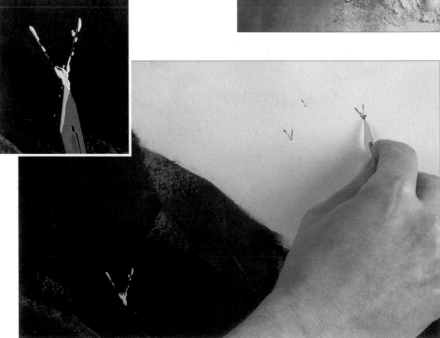

40 Pick up some titanium white on the blade of your craft knife and touch it twice to the rocks to create a seabird (see inset), then pick up some of the dark mix of Winsor blue (green shade) and burnt sienna and make three smaller birds in the same way in the background.

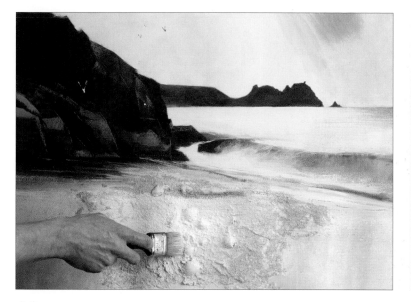

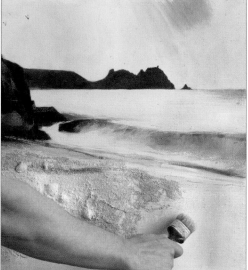

41 Use the 37mm (1½in) household brush to paint the centre of the beach with dilute titanium white.

42 Lay in the reflection of the top right part of the sky on the beach and sea below it, using the paint left on the brush.

43 Glaze the area where the headland meets the foreground rocks with a size 8 short flat/bright brush and dilute titanium white to knock it back and help differentiate the rock areas.

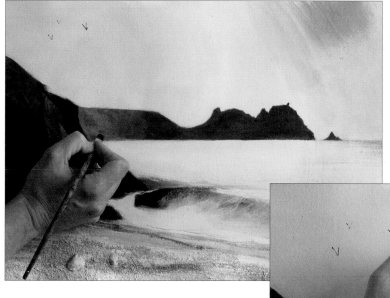

44 Add a subtle sun next to the gulls, using the size 2 round brush and titanium white.

Overleaf:
The finished painting

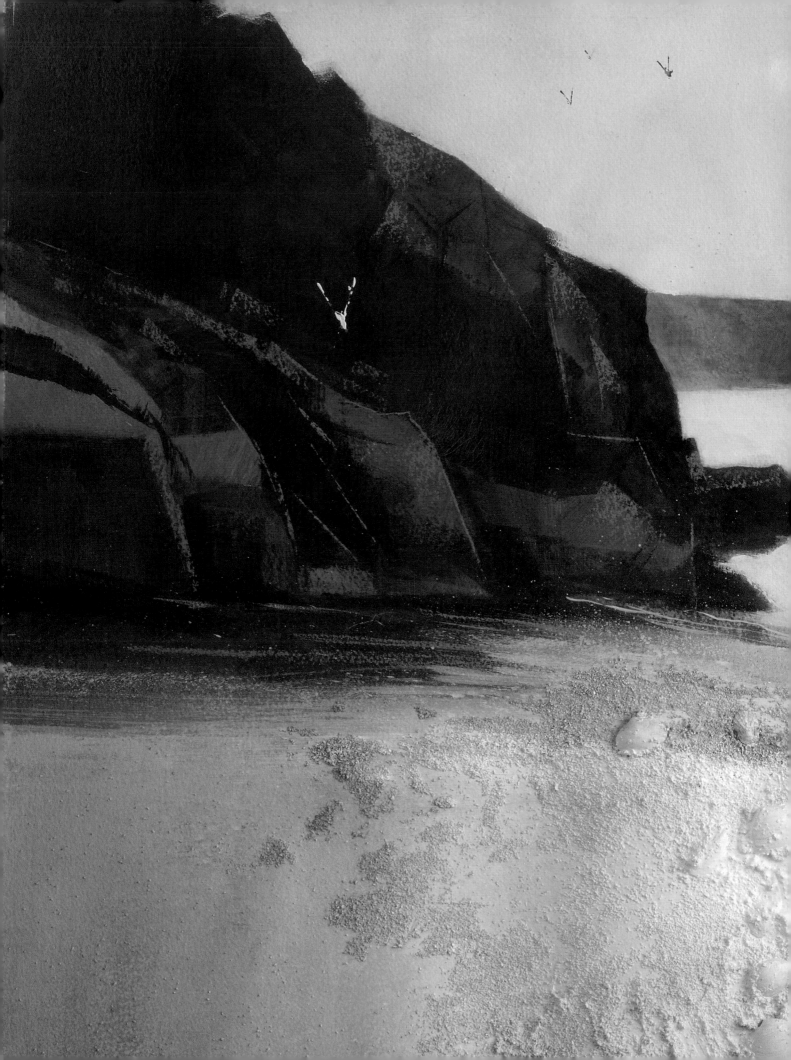

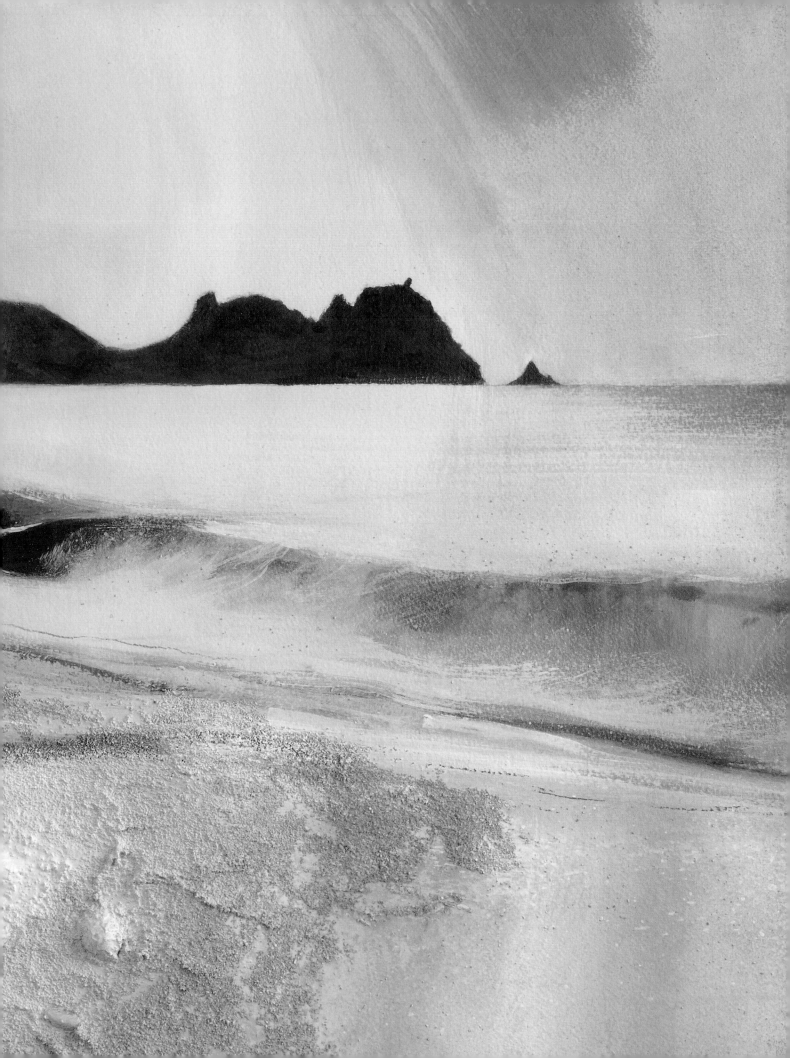

White Cliffs

These extraordinary cliffs are Old Harry Rocks in Dorset, England and mark the most easterly point of the Jurassic Coast, a UNESCO World Heritage Site. Made up of chalk and a touch of flint, they were formed sixty-five million years ago and now sit patiently gazing out to sea, waiting for artists to paint them.

The dazzling white of the ever-eroding cliffs helps to make the surrounding sea colour appear even more jewel-like.

Highlights and lowlights are easily added using a few swift strokes with my trusty Conté sticks. These simple marks combined with a few flicked sparkles help to bring the painting to life as well as adding a sense of scale.

You will need

Rough watercolour paper: 76 x 56cm (30 x 22in)

Paints: ultramarine blue, Winsor blue (green shade), burnt sienna, yellow ochre, titanium white

Brushes: 50mm (2in) household brush, size 28 short flat/bright, size 4 flat hog

Conté sticks: white, yellow, dark brown, cream

Painting board and easel

4B pencil

Bulldog clips

Palette knife

Toothbrush and scrap paper

Low-tack masking tape

1 Transfer the main shapes of the sketch to the watercolour paper using a 4B pencil, then secure the paper to your board using bulldog clips and place it on your easel.

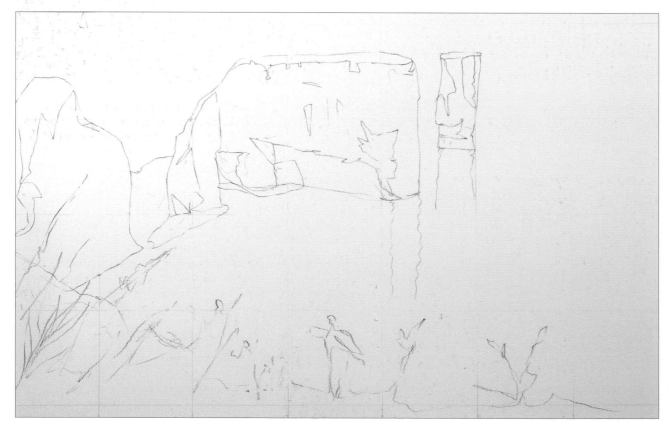

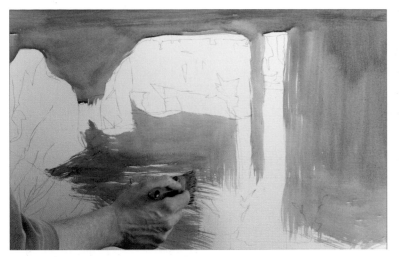

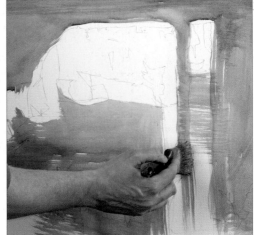

2 Use a 50mm (2in) household brush to lay in fairly dilute ultramarine blue over the sky and water. Use the edge of the brush to cut in around the cliffs.

3 Use the paint remaining on the brush to lightly draw horizontal touches over the reflections to suggest waves.

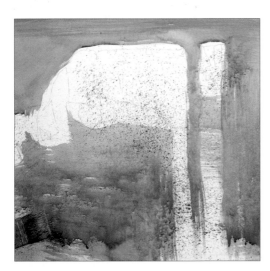

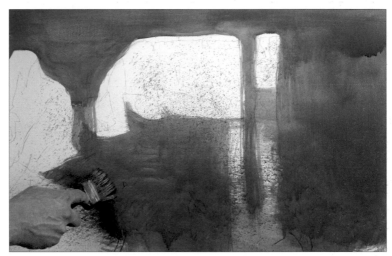

4 Reload the brush and spatter over the white areas, working more heavily over the foreground area. Allow to dry.

5 Dilute Winsor blue (green shade) and use the 50mm (2in) household brush to glaze it over the sea area. Use the same brush and colour to overlay the reflections of the pillars. Make the strokes bigger and more energetic in the foreground.

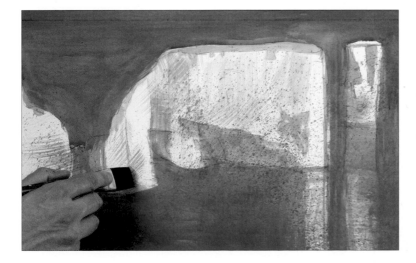

6 While the Winsor blue (green shade) is drying, use the size 28 short flat/bright with the same mix to block in some areas of shadow on the cliff face. Vary the pressure on the brush to achieve a mix of tones.

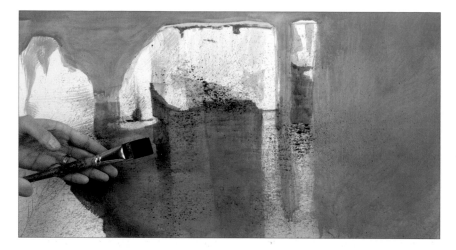

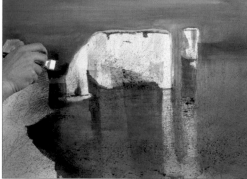

8 Continue developing the darks across the sea. Near the cliffs, use the edge of the brush to ensure sharp edges.

7 Still using the size 28 short flat/bright, make a dilute dark mix of Winsor blue (green shade) and burnt sienna. Use the edge of the brush to create angular strokes and establish the dark areas across the painting. For the reflected shadows in the sea, start near the base of the cliffs for the strongest application of paint, and gradually work downwards, and allow the paint to run out as you work to create a gradually fading glaze. Use the same mix to create spattering.

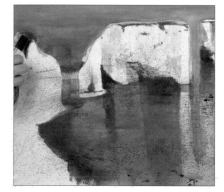

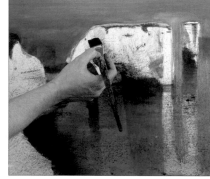

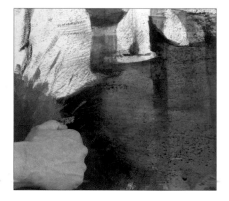

9 Make a less dilute dark mix with the same colours, and apply it to the side of the brush. Lightly draw it over the tops of the cliffs to suggest the texture of dark grasses. Use the same mix to enrich the very darkest areas.

10 Dilute the mix once again, and glaze some of the shadows on the cliff to give them some life. Use the different parts of the brush (side, edge, flat and corner) to develop the texture on the cliffs with tiny touches.

11 Block in the foreground with yellow ochre, then use the edge of the brush to suggest grasses and seedheads sticking out from this area.

12 Dilute the yellow ochre and suggest seaweed, discoloured rock and their reflections around the base of the rocks. Use the same mix to develop the grasses on the top of the cliffs.

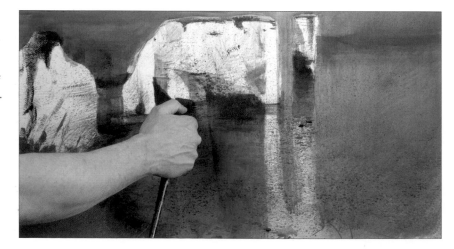

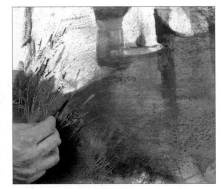

13 Use a size 4 flat hog brush to scumble burnt sienna into the grassy foreground area.

14 While the burnt sienna is still wet, use the palette knife to scrape the burnt sienna back through to leave some highlights giving the impression of grass stems.

15 Pick up some burnt sienna on the edge of the palette knife. Press it on to the surface and draw it down to create dark lines, following the lines of the existing stems.

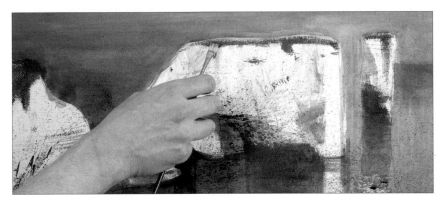

16 Use the burnt sienna remaining on the size 4 flat hog brush to add some very faint harmonising touches across the cliffs.

17 Scumble the dark burnt sienna and Winsor blue (green shade) mix lightly over the foreground.

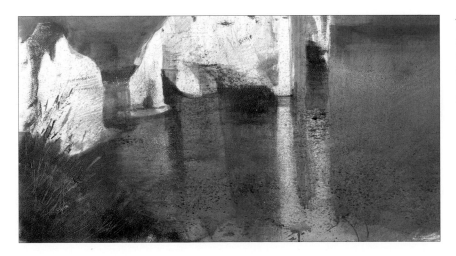

18 Pick up a touch of titanium white and a little water on your toothbrush and create texture on the cliff and sparkle on the water with a spattering action. Protect any areas you want to remain clean with some scrap paper.

19 Turn the painting upside-down and resecure it to your board. Place a strip of low-tack masking tape across the horizon.

20 Using the size 28 short flat/bright, draw a slightly diluted mix of Winsor blue (green shade) and titanium white across the whole horizon, starting from the masking tape.

21 Work down towards the top of the sky (i.e. the current bottom of the painting), adding more water to grade out the colour as you go.

22 Carefully remove the masking tape and rinse your brush. Using the clean damp brush, soften the horizon line with long horizontal strokes.

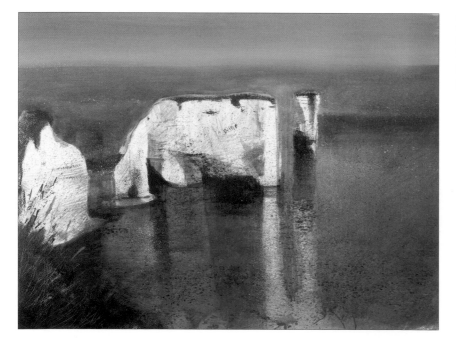

23 Turn the painting back up the right way and spatter the sea in the background with the Winsor blue (green shade) and titanium white sky mix.

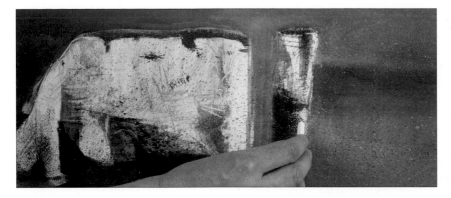

24 Use a white Conté stick to add strong highlights on the central cliffs and right-hand stack. Use the side for lines, the tip for touches and draw the whole crayon across for broken areas.

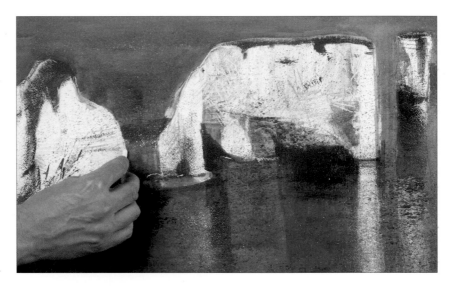

25 Continue to build up the texture across the cliffs with the white Conté stick, using less pressure to develop a variety of different marks and effects.

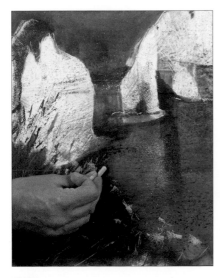

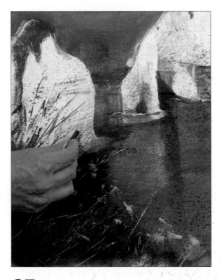

26 Use the yellow Conté stick to add a few touches to suggest flowerheads in the foreground.

27 Use dark brown and cream Conté sticks to make some final touches to the foreground and complete the painting.

Overleaf:
The finished painting

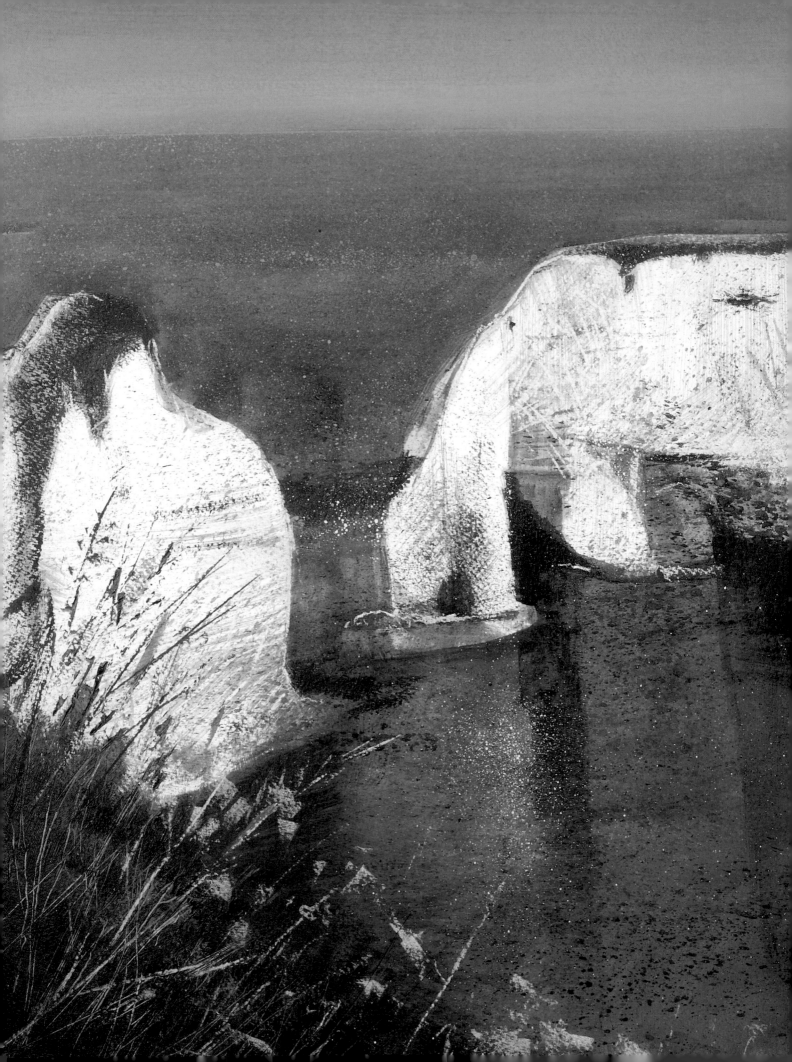

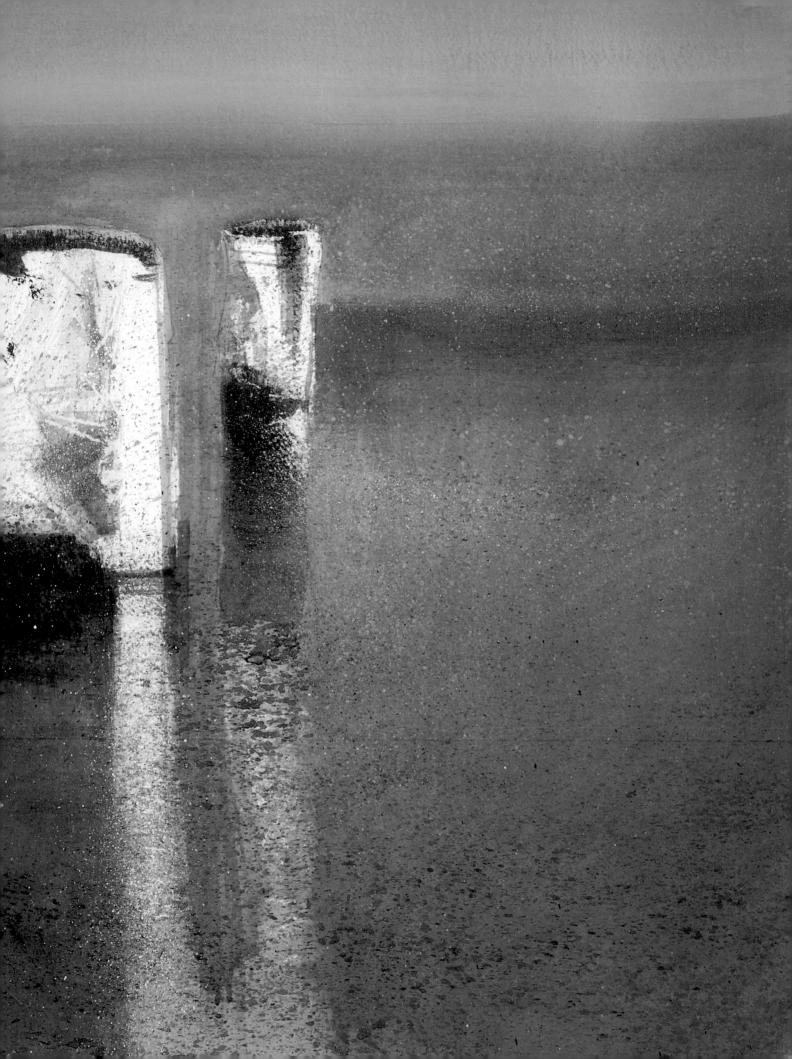

City Nights

New York, New York... this cityscape project could not be anywhere else, or could it? Try the techniques in this project to create energy and noise to your chosen city location.

When I first visited New York I was completely entranced; the neon, the noise, the rush, I loved it. But I puzzled at how to capture that energy. My brushstrokes were too meandering, too soft. I struggled to find the marks that screamed 'height', 'loud', and 'buzz' and 'dazzle'. Then I hit upon a solution: I would let the hard-edged graphics of advertising create the image for me, quickly and spontaneously – and all at a head-spinning angle.

You will need

Rough watercolour paper: 76 x 56cm (30 x 22in)

Paints: Winsor blue (red shade), cadmium yellow medium, cadmium red medium, titanium white, burnt sienna

Brushes: size 8 short flat/ bright, size 28 short flat/ bright, size 2 short flat/ bright

Conté sticks: white, pink, orange, dark blue

4B pencil

Brightly coloured advertising material from magazines

Spray mount

Radiator roller

Painting board and easel

Bulldog clips

Scissors, scrap paper and card

Toothbrush

1 Transfer the main shapes of the sketch to the watercolour paper using a 4B pencil, then secure the paper to your board using bulldog clips and place it on your easel.

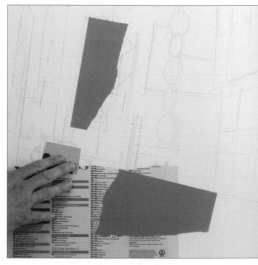

2 Search through your old magazines and select sections. Look for bright blocks and strips of colour for this busy, well-lit city. Use spray mount to secure the blocks to the surface, following the sketch loosely. Try to work intuitively, and not overthink your choice of collage pieces.

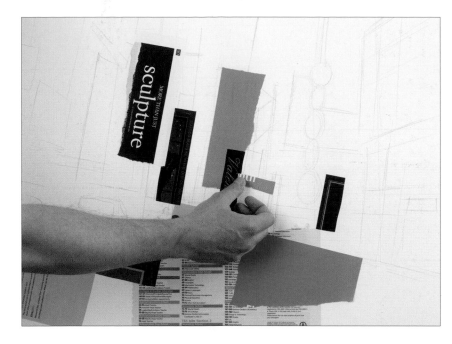

3 Continue to build up the collage. If you use large amounts of text, make sure that it is very small, so that the viewer is not tempted to try to read them. However, the presence of large, brightly-coloured text will give the impression of advertising, signage and shop hoardings.

4 As you continue to build up the collage, begin to overlay and overlap the new blocks over the existing ones, beginning to build up texture through collage. Aim to evoke the main areas by use of colour: the wet tarmac of the road looks effective with strong blocks of black and contrasting text, for example, while small black text on white paper can give the impression of reflective glass buildings.

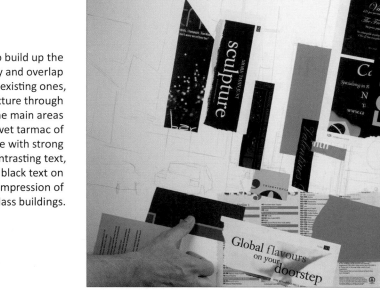

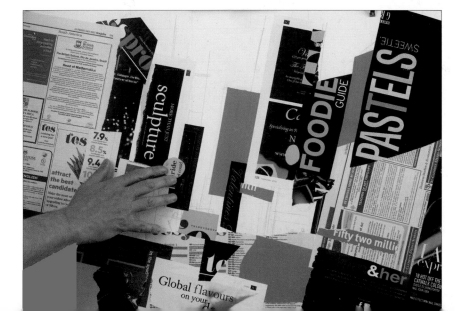

5 Once you have covered nearly all of the paper with rectangular and square blocks, try adding some different shapes such as circles and ellipses to add interest and detail.

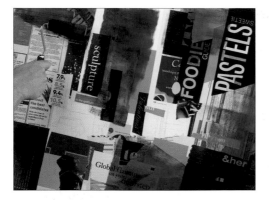

6 Using a radiator roller, apply slightly diluted Winsor blue (red shade) to the dark areas at the top of the painting and their reflections at the bottom. The roller makes it easy to create hard edges and evoke the geometric shapes of the buildings.

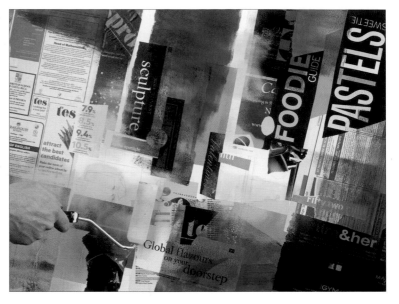

7 Start to suggest the large areas of colour with clean radiator rollers. Block in cadmium yellow medium for yellow reflected light. Aim to suggest a street level at an angle.

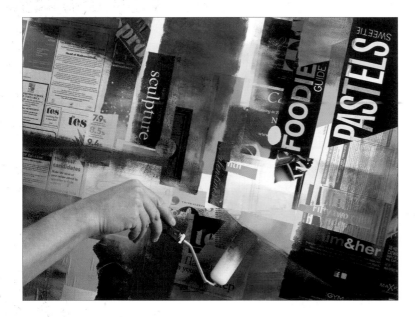

8 Pick up cadmium red medium on the edge of the roller and add a few hot touches across the painting. Start to create a focal point on the street level, by drawing short red lines that converge.

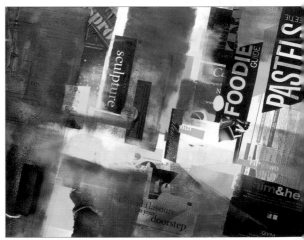

9 Swap back to the Winsor blue (red shade) roller and reload it lightly. Use the roller to overlay the edges of the painting. This darkens the edges, so that the brighter colours in the centre draw the eye. Note that the lighter load of paint results in glazing, with the brighter colours showing through slightly in places.

10 Make smaller marks by loading the edge of the roller only, and by using scrap paper as a mask.

11 Add a little titanium white to the Winsor blue (red shade) and overlay some of the areas again to develop some lighter areas.

12 Cut a 5 x 5cm (2 x 2in) piece of scrap card. Pick up some titanium white on the edge and touch it on the surface near the centre a few times to start to create detail. Even a few lines leading towards the focal points can suggest the shape of the street.

13 Continue to build up these white touches with the card. Create tiny marks with the corner of the card and larger marks by dragging the edge a little. Start to create perspective by making larger marks further from the focal point, and making only tiny ones in the focal point itself.

14 Make a dark mix of burnt sienna and Winsor blue (red shade) and make a few marks around the centre with a size 8 short flat/bright. Paint in the rear window and wheels of the taxicab on the lower left.

15 Cut in a negative shape to create the taxicab's outline with the same mix and brush. As you work away from the car, begin to dilute the paint and scumble it on to the surface.

16 Hold a straight length of scrap card up and use it to guide the edge of the brush to make some narrow lines near the car, parallel with the horizon. The card will act as a mask to protect the bottom of the painting and help keep the lines straight.

17 Glaze dilute burnt sienna over the right-hand side of the car and the area next to it.

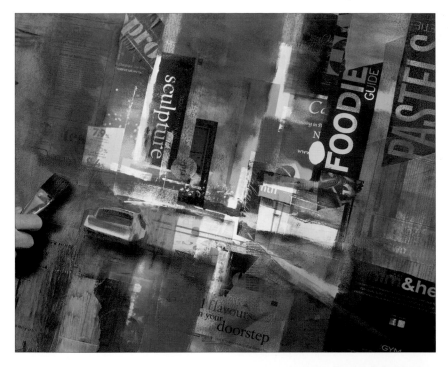

18 Use the size 28 short flat/bright to glaze dilute burnt sienna over very bright areas around the edges of the painting, in order to knock them back and draw the eye to the central focal point.

19 Make some more dark mix from undiluted burnt sienna and Winsor blue (red shade) and use the corner of the size 8 short flat/bright brush to pick out some silhouetted figures and details around the focal point.

Tip

As long as the dots representing the figures' heads are all at the same height, the viewer's eye will interpret them as people.

20 Use the corner of a 5 x 5cm (2 x 2in) piece of scrap card to pick up some of the dark mix and add dots and dashes in the same area.

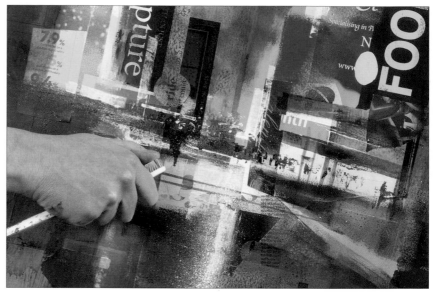

21 Pick up some dilute titanium white on your toothbrush and spatter a bright line down from the focal point to represent highlights on the wet tarmac. Hold the toothbrush quite close to the surface to control the spatter.

22 Lightly spatter titanium white across the figures on the foreground, keeping the lines roughly parallel to the horizon.

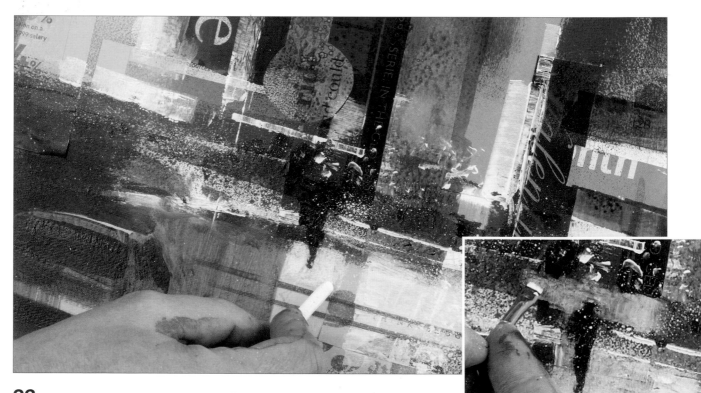

23 Use the white Conté stick to pick out the feet of the figure next to the taxi cab, then glaze dilute titanium white around his head and shoulders using a size 2 short flat/bright (see inset).

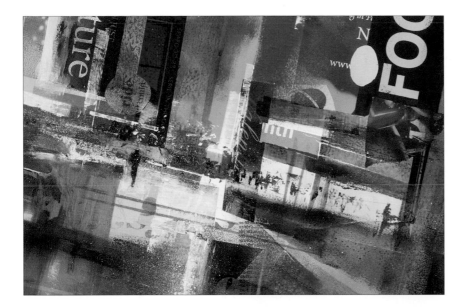

24 With a flicking motion and the pink Conté stick, add tiny dots and dashes around the figures and foreground at various angles to create movement.

25 Add in the rear lights of the taxi cab and a few random details over the middle ground using an orange Conté stick.

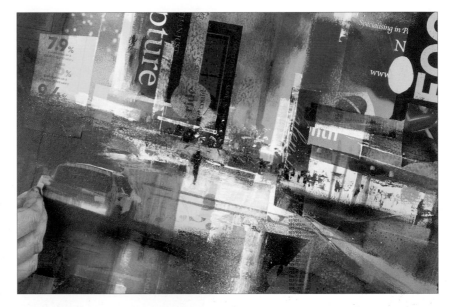

26 Make some final detail dots, dashes and vertical strokes over the midground and focal point using a dark blue Conté stick.

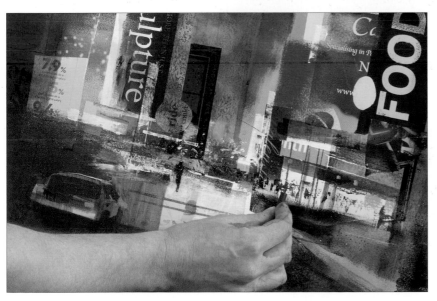

Overleaf:
The finished painting

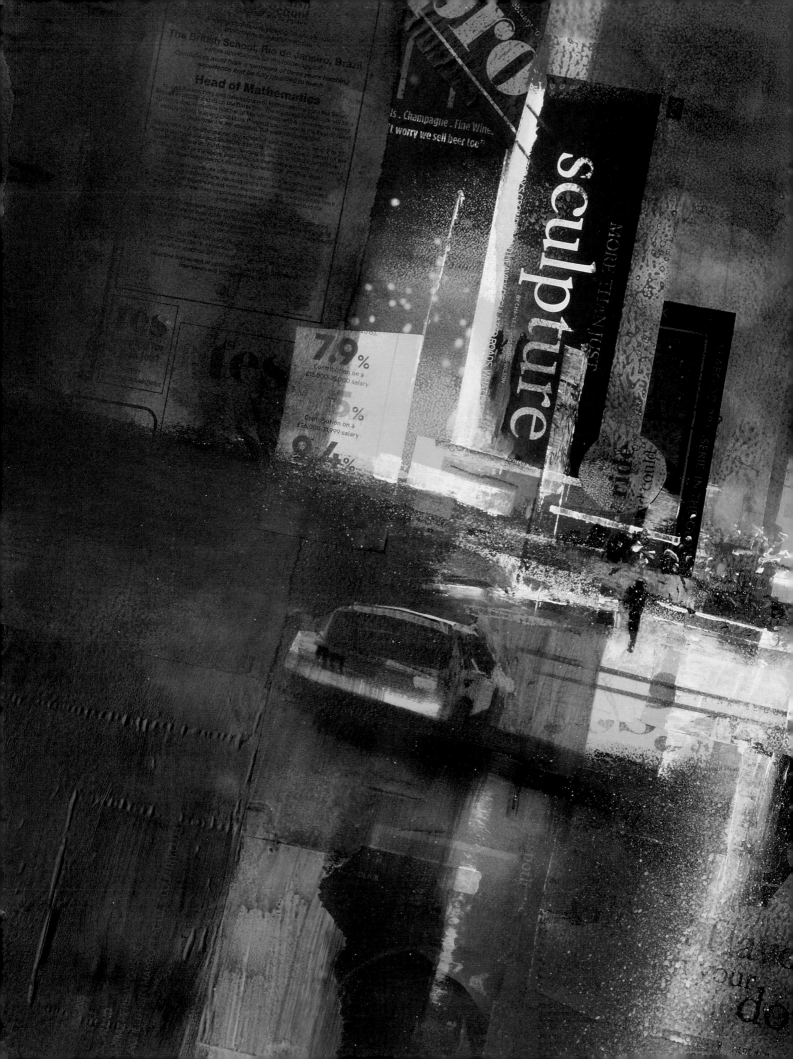

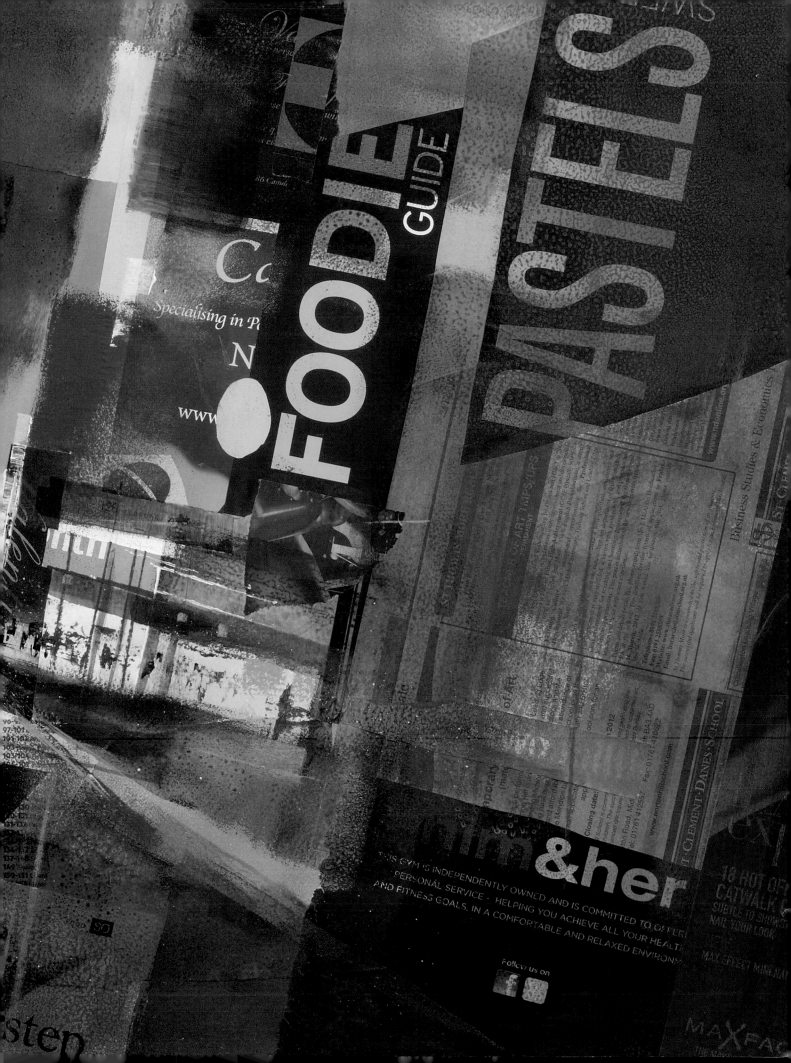

Mountain Range

I love to paint mountains, hills and dramatic landscapes but sometimes they can be tricky subjects. How do you create that sense of scale and majesty?

I try to capture these elusive elements by creating texture – in this project I use radiator rollers and roughened surfaces. These methods quickly build up layered areas of implied detail, and it is this implied detail that adds scale. Well, that and adding tiny trees to the foreground!

You will need

Rough watercolour paper: 76 x 56cm (30 x 22in)

Paints: cadmium yellow medium, yellow ochre, burnt sienna, Winsor blue (red shade), titanium white, ultramarine blue

Brushes: size 28 short flat/bright, size 8 short flat/bright

Conté sticks: cream, white, light blue

4B pencil

Radiator rollers

Painting board and easel

Bulldog clips

Scrap paper and card

Toothbrush

1 Transfer the main shapes of the sketch to the watercolour paper using a 4B pencil, then secure the paper to your board using bulldog clips and place it on your easel.

2 Pick up cadmium yellow medium on a radiator roller and block in the mountains in the middle distance and background fairly roughly.

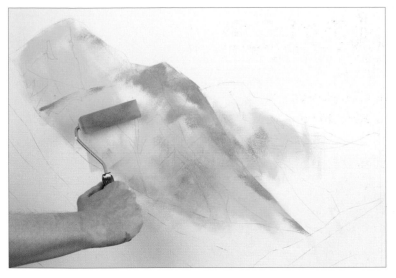

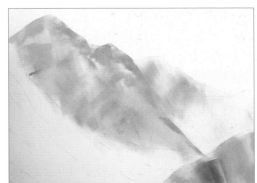

3 Pick up a little yellow ochre on the roller, roll it once or twice on scrap paper to remove the excess, and then lightly roll it over the mountain in the middle distance to create texture. Use the edge of the roller to pick out the edges and contours of the mountains.

4 Build up the peak on the lower right in the same way, picking up cadmium yellow medium and yellow ochre on the roller.

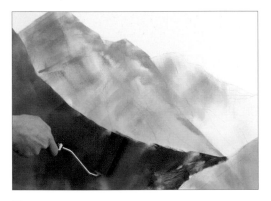

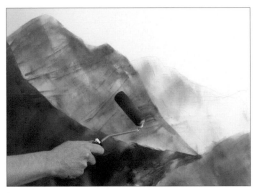

5 Pick up burnt sienna on the same roller and block in the foreground fairly roughly, following the shape of the mountain with the edge for a sharp delineation.

6 Develop the contours and dark areas on the middle distance mountains with the burnt sienna remaining on the roller.

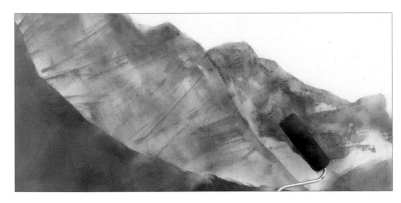

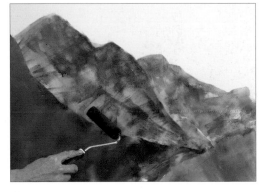

7 Pick up very dilute Winsor blue (red shade) on a clean new roller and glaze the dark areas of the background peaks by rolling over them lightly so the underlying colour shows through. Use the edge of the roller for more controlled shapes.

8 Glaze the dark areas of the mid-distance mountains in the same way.

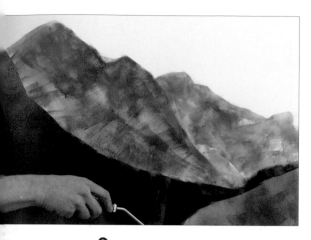

9 Pick up less dilute Winsor blue (red shade) on the blue roller and glaze the foreground mountains in shadow quite strongly, again following the ridge with the edge of the roller.

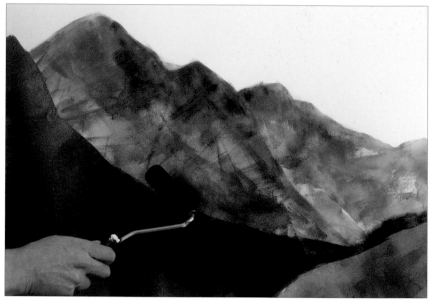

10 Use the remaining paint on the roller to enrich the shadow on the peaks in the midground and background. Use the edge to make short textural marks.

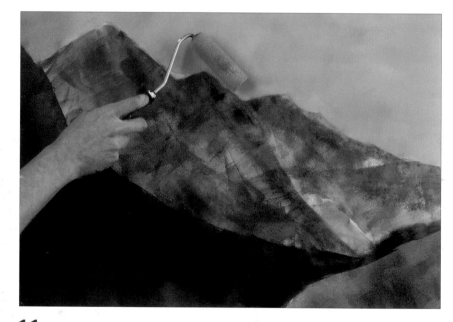

11 Make a mix of titanium white and ultramarine blue and use it to block in the sky. Cut into the peaks with the edge of the roller to suggest the hard, jagged structure of the mountains.

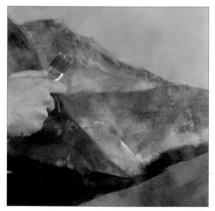

12 Use a size 28 short flat/bright to glaze the background mountains with a very watered-down mix of ultramarine blue and titanium white.

13 Pick up pure undiluted titanium white with the corner of the brush, and touch it lightly on to the surface of the paper to suggest areas of snow following the contours of the background mountains.

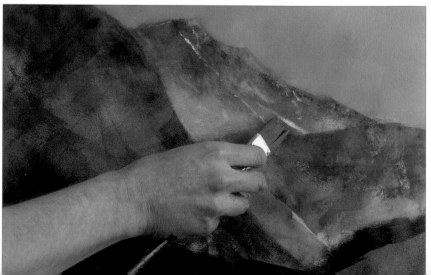

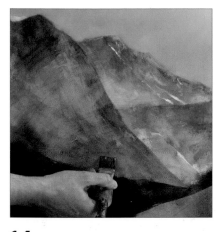

14 Pick up some of the very dilute titanium white and ultramarine blue mix on the size 28 short flat/bright brush and glaze the midground area.

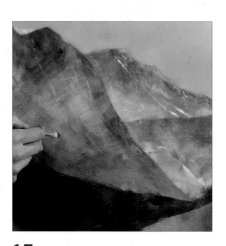

15 Switch to the size 8 short flat/bright and add more titanium white to the mix. Use this to add a few details to suggest contours.

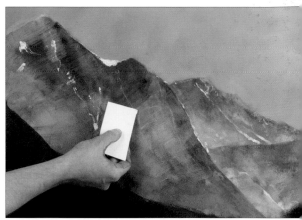

16 Use the corner of a 5 x 10cm (2½ x 4in) piece of scrap card to pick up some pure undiluted titanium white and add some tiny touches and streaks of white to represent snow-capped ridges and create a sense of scale.

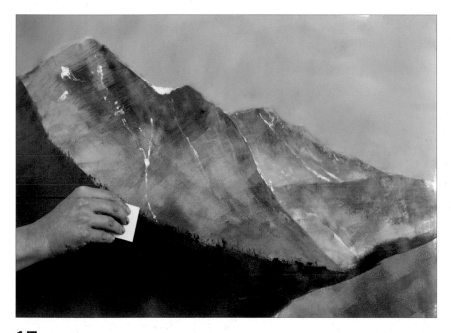

17 Make more of the dark mix from Winsor blue (red shade) and burnt sienna. Develop the sense of scale by tearing the scrap card in half and using the torn edge to add the silhouetted trees on the foreground ridge. Do not make them stand in a row like soldiers: add a sense of natural randomness by applying them at slightly different angles and heights.

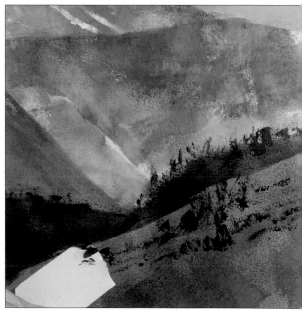

18 Continue across the right-hand area of foreground, making slightly larger shapes with the same mix and piece of card.

19 Dilute the dark mix and use an old toothbrush to spatter the foreground on the lower right to create texture.

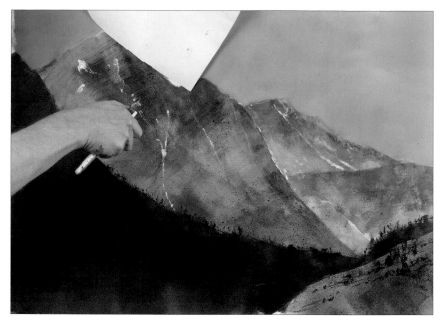

20 Continue spattering the dark mix across the mountains, using a piece of scrap paper to protect the sky.

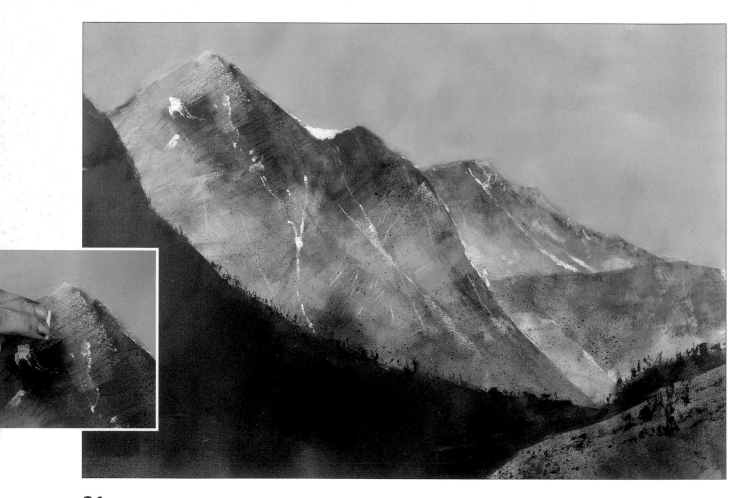

21 Draw the body of the cream Conté stick lightly across the peak of the left-hand mountain to pick up the texture of the paper (see inset), then use the tip to make marks across the midground mountains to represent gulleys, striations and similar features.

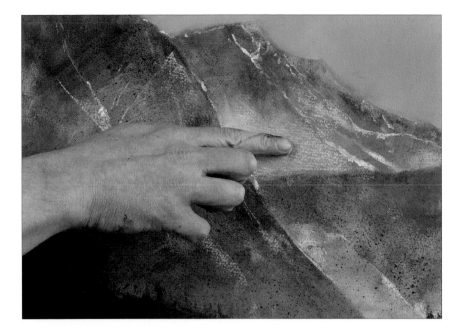

22 Create depth by drawing the body of the white Conté stick across the background mountain, to create recession, suggest mist and develop the sheer size of the mountain. Gently soften the Conté into the surface with a finger.

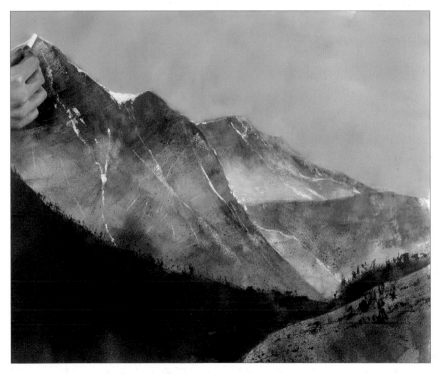

23 Add some strong highlights to the crest of the mountains with the white Conté stick.

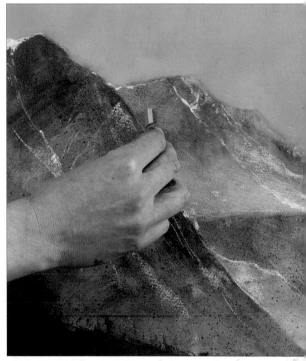

24 Knock back the distant peaks further using the light blue Conté stick to finish.

Overleaf:
The finished painting

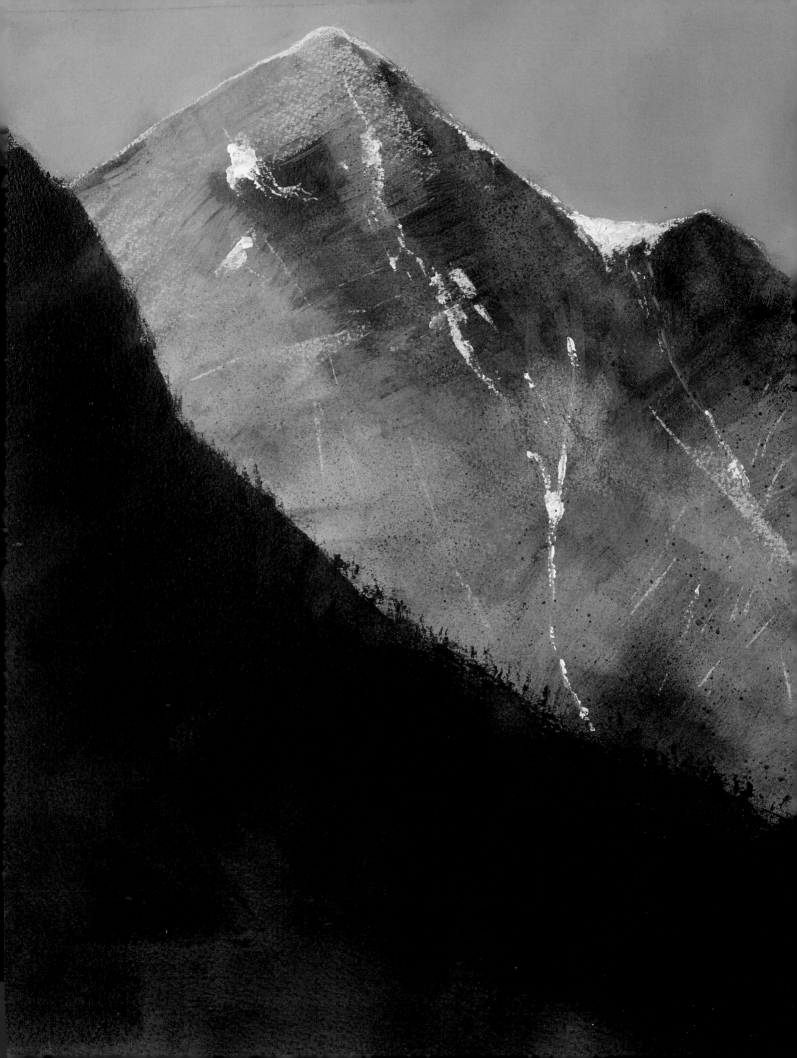

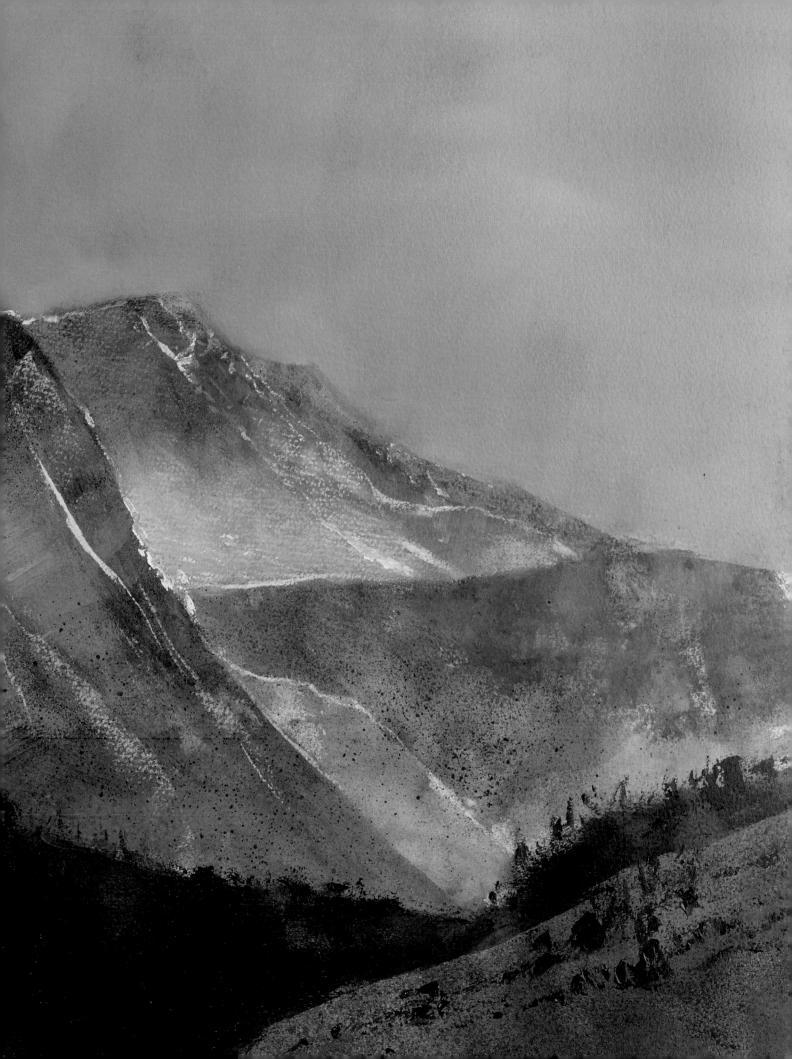

Woodland Evening

Woodlands, forests and trees are amongst the trickiest of subjects to paint. With thousands of branches to contend with, not to mention the millions of leaves, if we accurately painted each one we would be here all day, and I prefer fast, effective results to keep the energy and enthusiasm high.

By simplifying the image, by breaking it down into simple steps, darks, lights and mid tones, you will be able to knock the painting into shape pretty quickly.

Again the radiator roller comes into its own and by using different techniques and parts we are able to create large areas like trunks and dark shadows and also spindly branches and twigs.

You will need

Rough watercolour paper: 76 x 56cm (30 x 22in)

Paints: cadmium yellow medium, burnt sienna, Winsor blue (red shade), titanium white

Brushes: 37mm (1½in) household brush, size 28 short flat/bright, size 8 short flat/bright

Conté sticks: brown, yellow, cream, sienna, orange

4B pencil

Radiator roller

Painting board and easel

Bulldog clips

Piece of sponge

Kitchen paper

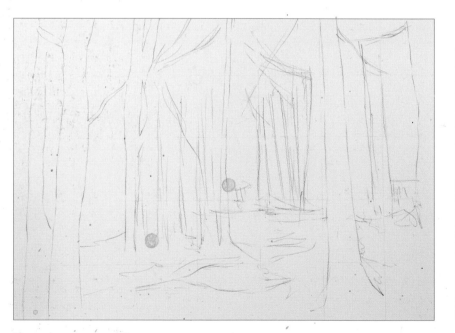

1 Transfer the main shapes of the sketch to the watercolour paper using a 4B pencil, then secure the paper to your board using bulldog clips and place it on your easel.

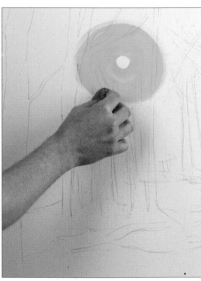

2 Using a piece of household sponge, pick up some slightly diluted cadmium yellow medium and draw a spiral out from the light source (the sun).

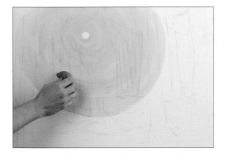

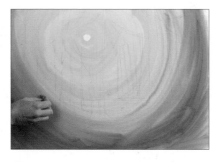

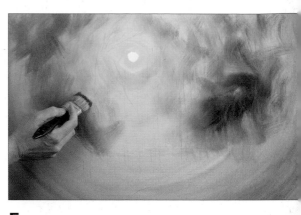

3 Continue to expand the spiral, diluting the paint slightly as you work outwards.

4 Still expanding the spiral, introduce more and more burnt sienna until the bottom is pure (though slightly dilute) burnt sienna.

5 While the paint is still wet, use a 37mm (1½in) household brush to scumble on small amounts of pure burnt sienna away from the sun, using quite random strokes.

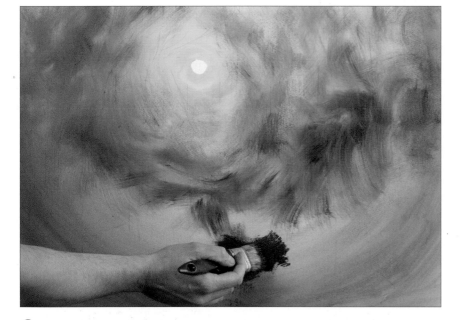

6 As you work into the foreground and away from the sun, use larger, stronger strokes.

Tip

Holding your brush as shown gives you great freedom of brushstrokes. Just flick your wrist this way and that for loose strokes.

7 Once you have completed brushing on the burnt sienna base (see inset), spatter the same slightly diluted colour across the painting, just above the middle, to start to suggest autumn foliage.

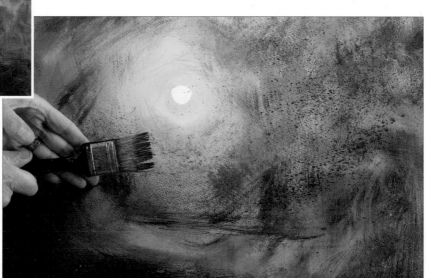

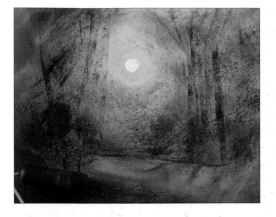

8 Mix Winsor blue (red shade) with burnt sienna to make a dark mix. Dilute it slightly and pick it up on a radiator roller. Apply the paint lightly using the edge of the roller to suggest the background trees. Increase the pressure you use to make the trees stronger as you advance.

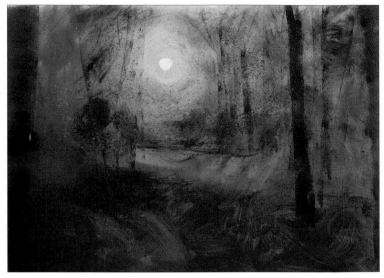

9 Make a less dilute mix of the same colours and roll in the foreground trees, making them bigger and longer than the background trees. Make a strong tree on each side that extends from top to bottom.

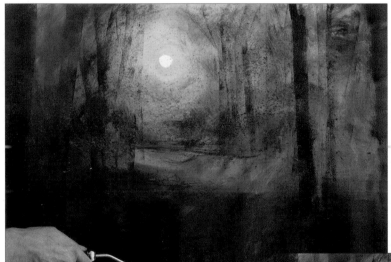

10 With the paint remaining on your roller, darken the forest floor in the foreground by using little pressure and horizontal movements.

11 Develop the trees with a few branches, applied with light strokes of the roller and the same mix.

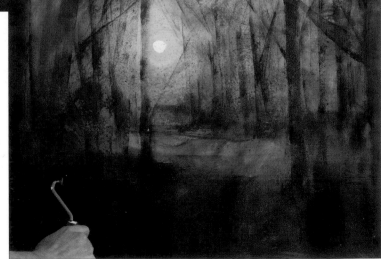

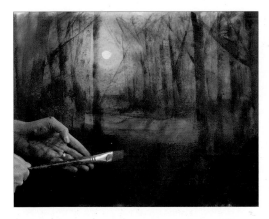

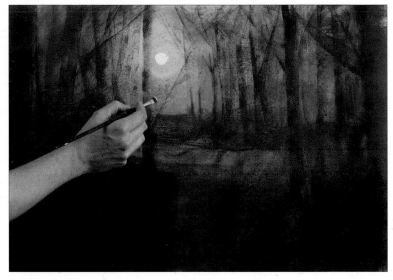

12 Darken the foreground and edges with the mix of Winsor blue (red shade) and burnt sienna, applying the paint with the size 28 short flat/bright brush. Lightly scumble the surface of the paper, then spatter the same area with the paint remaining on the brush.

13 Mix cadmium yellow medium with burnt sienna and a little titanium white and use the size 8 short flat/bright to scumble the surface between the background trees, helping to bring them out with negative painting.

Tip

Adding titanium white to a mix helps to give it opacity and covering power.

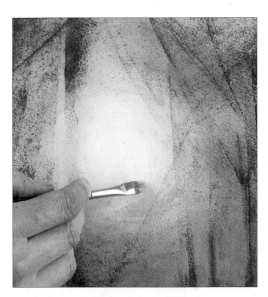

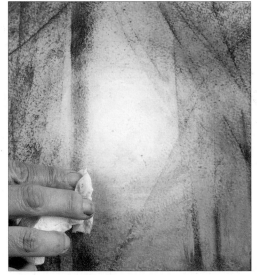

14 Scumble slightly diluted titanium white around the sun. Work with curved, circular marks outwards from the sun and scumble the paint over everything: the background, trees and branches, in order to suggest glare.

15 Use a piece of clean kitchen paper to lift out the wet white paint away from the trunk of the tree, to create a halo effect around the silhouetted trunk.

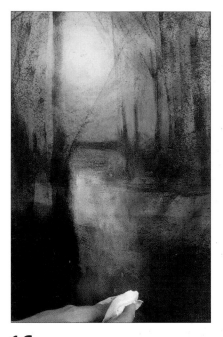

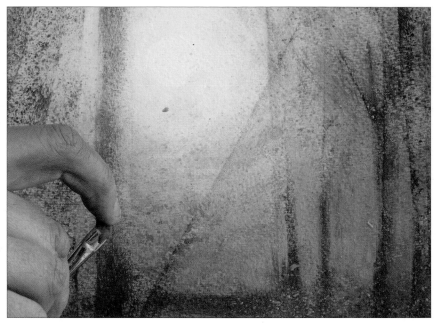

16 Still using the size 8 short flat/bright with dilute titanium white, scumble the woodland floor below the sun, then dab the paint with the kitchen paper to lift out some marks.

17 Pick up some of the dilute cadmium yellow medium, burnt sienna and titanium white mix on the size 8 short flat/bright brush, and spatter it around below the sun by drawing your finger across the tip.

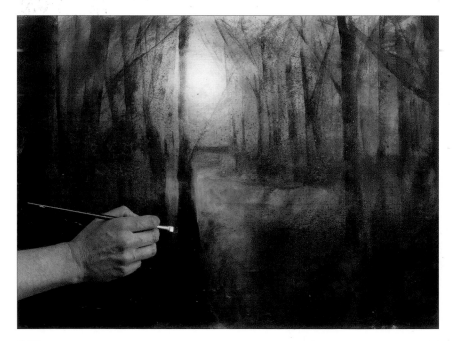

18 Glaze the same very dilute mix over the white on the woodland floor using the size 8 short flat/bright.

19 Glaze the same colour over the forest floor around the trees, developing the shapes through negative painting.

20 Spatter the mix over the painting, with emphasis on the upper part and around the sun.

21 Dilute the mix further and heavily spatter the foreground. Encourage the mix to drip and dribble down the surface, as this creates a visual lead from out of the painting towards the focal light source.

22 Use a brown Conté stick with curt marks to suggest some branches, concentrating on the area around the sun.

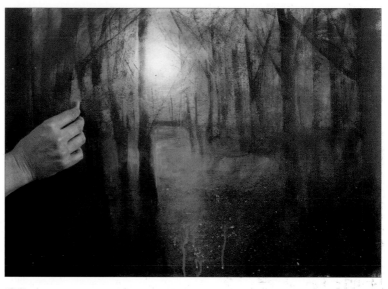

23 Continue to build up the foliage and suggest highlights and foliage with Conté sticks in a variety of autumnal colours (yellow, cream, sienna, orange and brown).

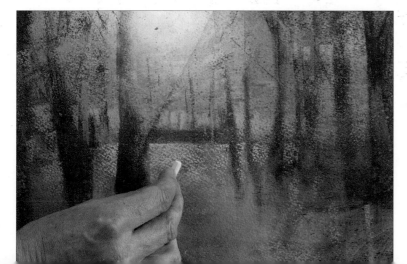

24 Emphasise the horizon line below the sun with a cream Conté stick to finish.

Overleaf:

The finished painting

103

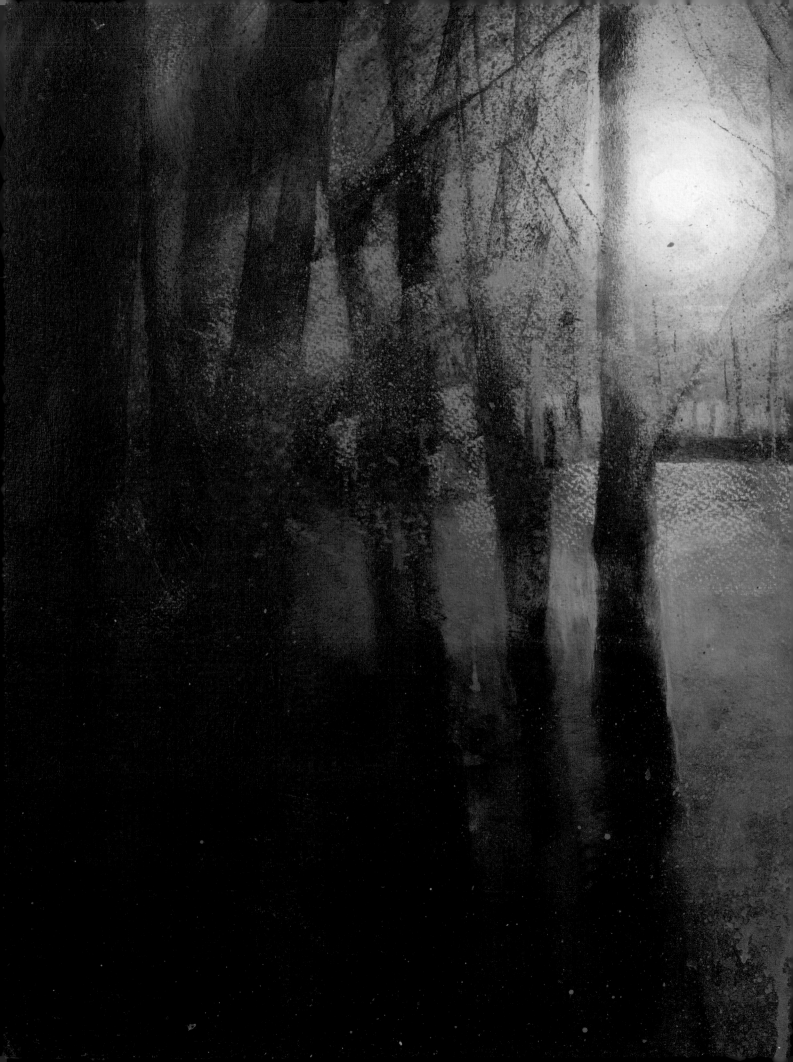

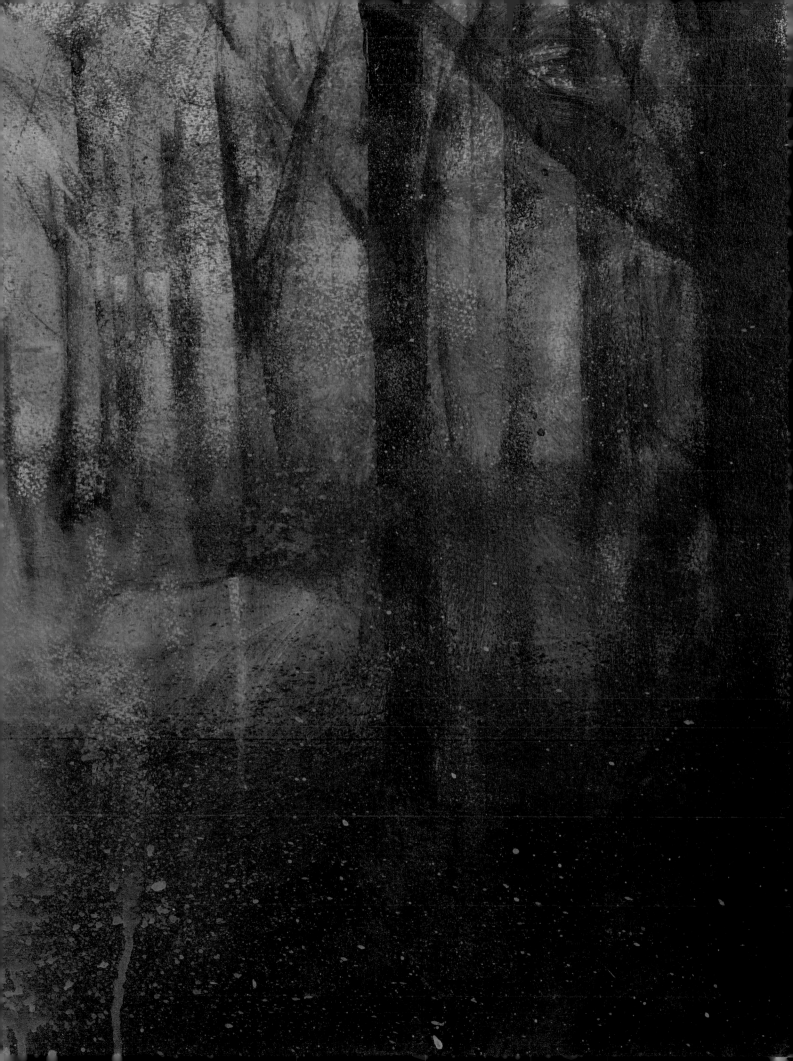

Coastal Town

So I find myself in Croatia, with bright sun, rich purple shadows, sardines and heat. The orange rooftops contrast wonderfully with the azure sea, and the verticals of bell towers, spires and television aerials create dramatic points of interest against the horizontal rooflines.

I am always happy to move, change and edit elements in my paintings, and with this in mind I decide to remove the smaller second tower (as shown in the drawing) to give more emphasis to the larger church tower. Never feel that you must include everything from the scene or photograph: be selective, and be choosy.

It's time for more collage – let's get those scissors and magazines at the ready.

You will need

Rough watercolour paper: 76 x 56cm (30 x 22in)

Paints: Winsor blue (green shade), titanium white, ultramarine blue, burnt sienna

Brushes: 50mm (2in) household brush, size 28 short flat/bright, size 2 filbert, size 8 short flat/bright, size 2 rigger

Conté sticks: warm brown, cream, grey

4B pencil

Painting board and easel

Masking tape

Warm-coloured magazine cuttings and fine newsprint

Spray mount

Small pieces of foam rubber

Scrap card

Radiator roller

Indian ink

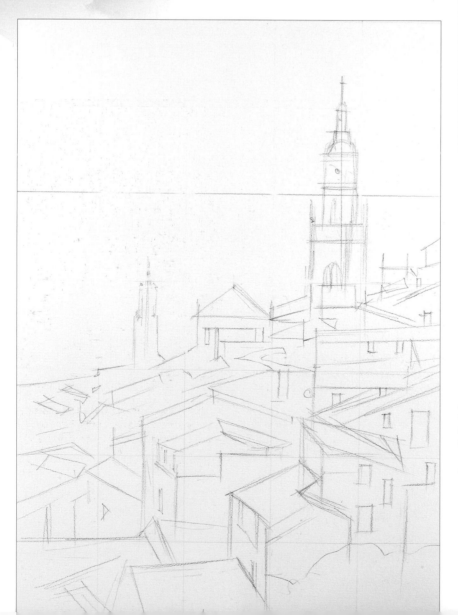

1 Transfer the main shapes of the sketch to the watercolour paper using a 4B pencil, then secure the paper to your board using masking tape and place it on your easel.

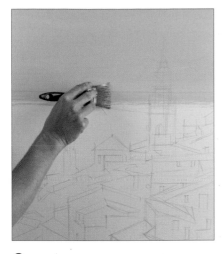

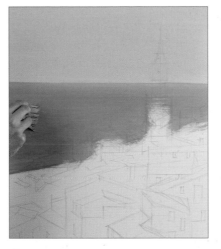

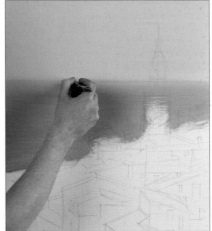

2 Tint Winsor blue (green shade) with plenty of titanium white and use the 50mm (2in) household brush with horizontal strokes to paint in the sky and work into the top of the sea.

3 Add more Winsor blue (green shade) and a little ultramarine blue to paint in the sea area, working back up to the horizon and blending the colour with the wet paint already there. At this point, I decided that I did not like the smaller tower, as it might draw attention from the main tower – so I simply painted it out!

4 Wipe excess paint off the brush and use a few soft strokes to blur the horizon line between the sea and sky.

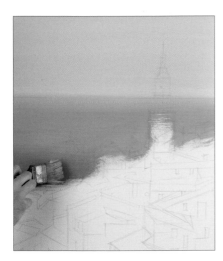

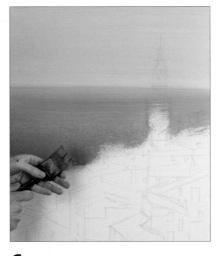

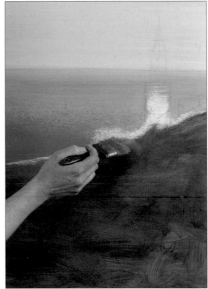

5 Add more Winsor blue (green shade) and ultramarine to the mix and darken the sea nearer the bottom of the painting, blending the colour in with the existing paint.

6 Use the paint remaining on the brush, spatter the area of sea nearer the bottom of the painting. Allow the paint to dry before continuing.

7 Clean your brush, and then scumble burnt sienna over all of the buildings. Leave a small gap between the town and the sea.

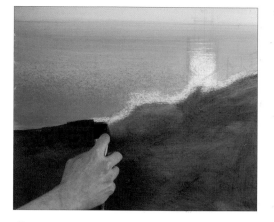

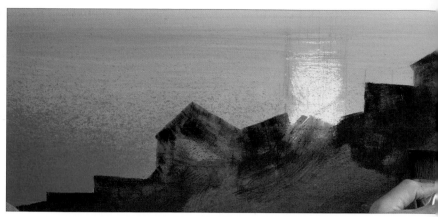

8 Change to the size 28 short flat/bright and pick up burnt sienna. Use the edge of the brush to fill the gap and create a sharp delineation between the sea and rooftops.

9 Blending the stronger colour in with the softer scumbled colour below, continue along the roofline, creating sharp rooftops and geometric shapes, and blending the colour into the paint below.

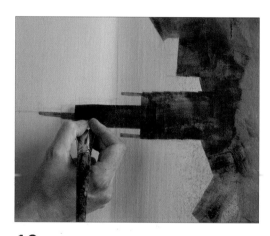

10 Paint in the larger tower with the stronger colour. Turn the board on its side if you find it easier to cut in with the edge of the brush.

11 Still using burnt sienna with the size 28 short flat/bright, begin to paint in the shadows of the town buildings (see inset). Use the edge of the brush to establish the hard lines of the rooftops, then blend the paint away into the existing base colour, using a scumbling motion.

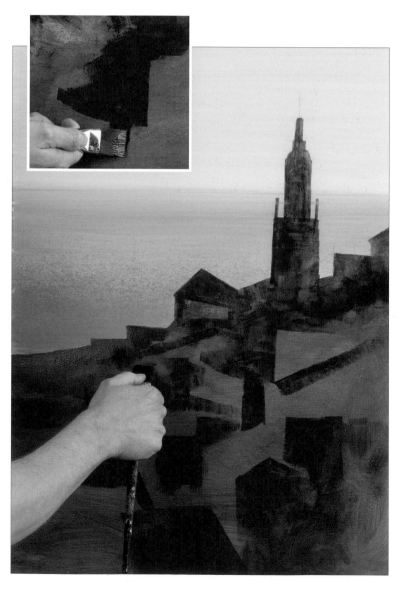

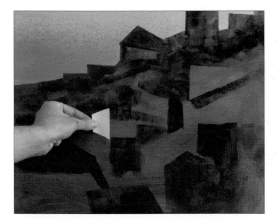

12 Search through your old magazines and cut out geometric shapes in colours lighter than the burnt sienna. Block advertisements are a good source of light-toned solid colours.

13 Start to build up the collage by spray mounting the geometric shapes to the surface in areas of highlight.

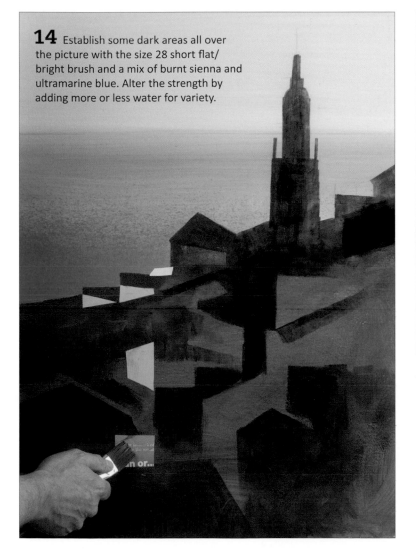

14 Establish some dark areas all over the picture with the size 28 short flat/ bright brush and a mix of burnt sienna and ultramarine blue. Alter the strength by adding more or less water for variety.

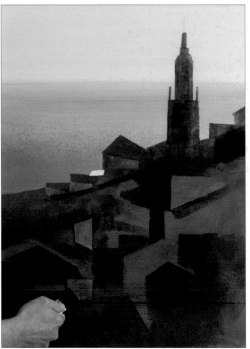

15 Still using the size 28 short flat/bright brush, glaze dilute burnt sienna over the areas of collaged geometric shapes in the town.

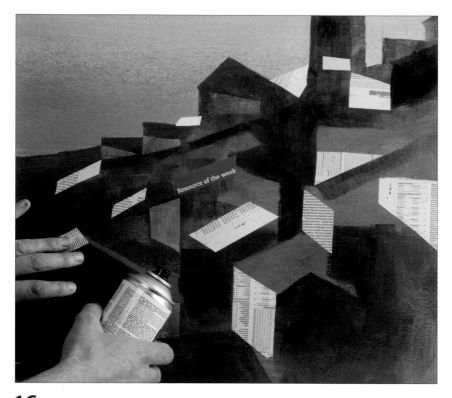

16 Select some fine newsprint and warm red magazine pieces, and secure them to the painting with spray mount to build up a jumble of roof and building pieces. Fine newsprint is great for grey textured walls as it has broken lines and a variety of patchwork tones.

17 Glaze the collaged areas with a very dilute dark mix (burnt sienna and ultramarine blue). Apply the paint loosely: do not feel you can not go over the edges.

18 Once dry, find smaller areas of warm colours from your magazines and add small sections to the rearmost buildings and rooftops.

19 Afix a big dark area to the foreground on the right.

20 Overlay the new collaged areas with burnt sienna and ultramarine blue glazes, and use a stronger mix of the two for the darker foreground.

Tip

I decided I did not like the pattern on the collage piece I originally selected for the foreground (see step 19), but acrylics make it easy to overlay, and fix parts of which you are not fond (see step 20). Feel free to change and adapt as you work to keep spontaneity and freshness in your painting.

21 Use a radiator roller to apply some of the dark mix (burnt sienna and ultramarine blue) around the rest of the foreground, using the edge of the roller for smaller areas.

22 Continue to build up the small rooftops in the distance with collage, then glaze some of them using the size 2 filbert with burnt sienna.

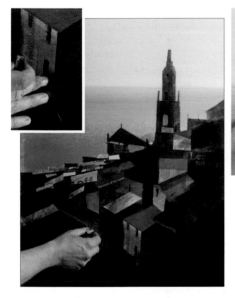

23 Pick up some of the dark mix on a bit of foam rubber and use it to stamp windows, details and chimney shadows in the foreground, blending the colour in a little with a finger (see inset).

24 Draw the body of a warm brown Conté stick horizontally across the tower to suggest highlights on the facade (see inset), then pick out details with the tip. Swap it out for the cream Conté stick and draw the body across the right-hand side of the tower for highlights.

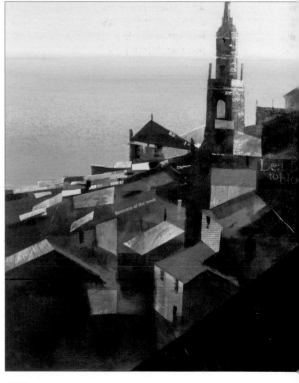

25 Pick out some sharp highlights on the rooftops using a grey Conté stick.

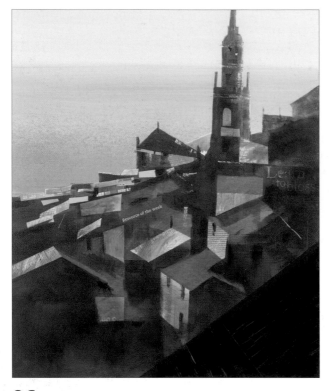

26 Knock back the cream highlights on the tower with a dilute glaze of burnt sienna applied with the size 8 short flat/bright brush.

27 Paint the edge of a 5 x 10cm (2 x 4in) piece of scrap card with burnt sienna and stamp it to the right of the tower to create a couple of vertical strokes.

28 Use a size 2 rigger to touch in a few small details with black Indian ink, such as streetlamps, windows and textural details.

Opposite:

The finished painting

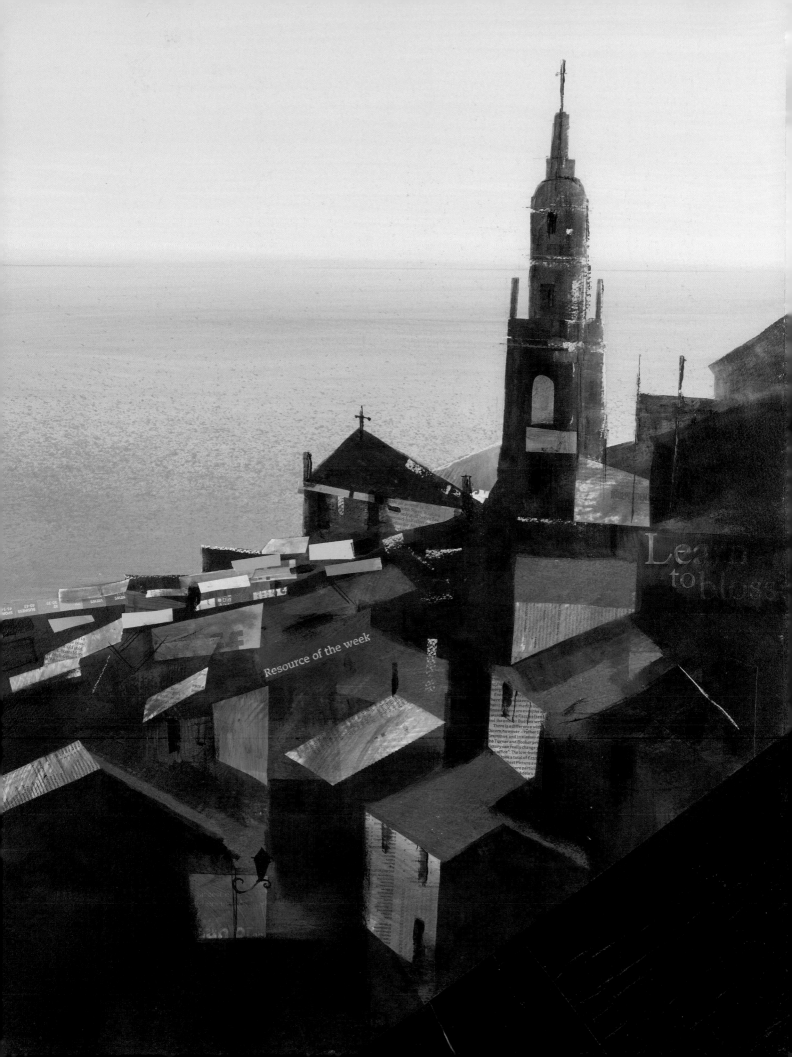

Fishing Harbour

My fishing harbour paintings are often compositions based on several sketches and drawings of many different harbours. By using this approach I am able to combine certain elements that either appeal to me or help to create a more interesting result.

In this example we are aiming to create the atmosphere of an early evening quayside, that time of day when the working harbour is beginning to wind down and the tourists are coming out to play.

The majority of the surface area is very simply painted. This lets the viewer imagine and create a lot of the implied detailing. The figures help to create movement and to draw the eye towards certain areas of the painting.

You will need

Rough watercolour paper:
76 x 56cm (30 x 22in)

Paints: cadmium yellow medium, cadmium red medium, burnt sienna, Winsor blue (green shade), titanium white

Brushes: size 28 short flat/bright, size 2 filbert

Conté sticks: red, pink, yellow, blue

4B pencil

Painting board and easel

Masking tape

Sponge

Radiator roller

Kitchen paper

Brightly-coloured advertising material from magazines

PVA glue

Craft knife

Foam rubber

Straight edge

Toothbrush

1 Secure your watercolour paper to the board with masking tape, place it on your easel, then use a 4B pencil to make some simple initial shapes. The focal point of this painting will be one third down from the top in the centre, so add some smaller geometrical shapes to add interest at this point (see inset).

2 Dampen a piece of sponge, use it to pick up some cadmium yellow, and sponge the colour on to the top right area. Allow the paint to drip down.

3 Pick up cadmium red with the same sponge and block in the top left. Allow the colour to blend with the yellow in the sponge and on the paper to produce orange hues, and bring it down into the sea slightly.

4 Pick up burnt sienna and rub the colour in on the jetty on the right, applying the colour fairly randomly to produce some thicker and some thinner areas. When you have nearly run out of paint on the sponge, sponge a little of the remaining colour into the top right.

 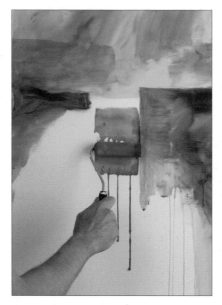 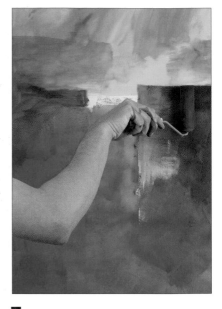

5 Working quickly while the paint is still wet, deepen the quayside on the left with burnt sienna.

6 Pick up a slightly diluted mix of Winsor blue (green shade) and a little titanium white with the radiator roller. Place it on the waterline between the jetties and use near-vertical strokes to block in the water on the lower left.

7 Blur the boundaries of where the right-hand jetty finishes by taking the blue below it and then up into it.

8 Use the paint remaining on the edge of the roller to suggest a row of rooftops on the top left and top right.

9 Build up the central area with the very last paint on the roller.

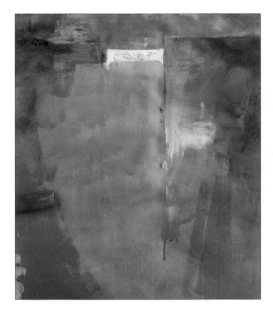

10 Reload the roller with the same dilute mix of Winsor blue (green shade) and a little titanium white. Glaze the edges of the painting to darken them.

11 Use a fresh roller head to pick up pure titanium white. Starting from between the jetties, use short back-and-forth motions to block in the sea.

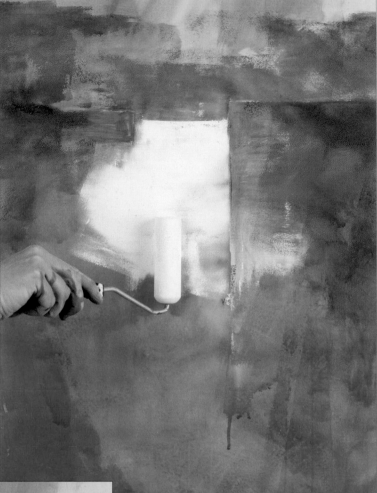

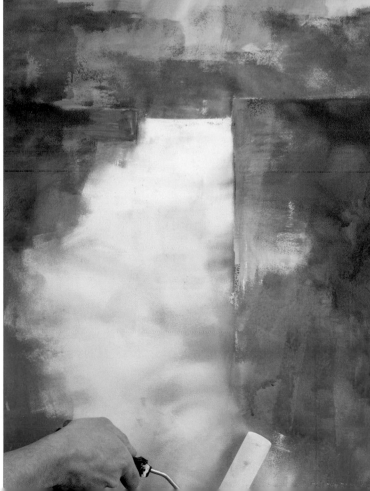

12 Pick up a touch of water on the roller along with the white, and draw longer back-and-forth motions around in a rough crescent over to the left and then down to the lower right.

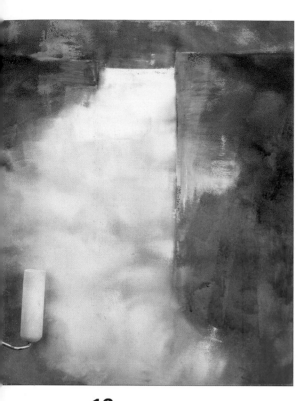

14 Load the roller with more titanium white and create a light source above the centre.

13 Create texture on the left-hand side with the small amount of paint remaining on the roller.

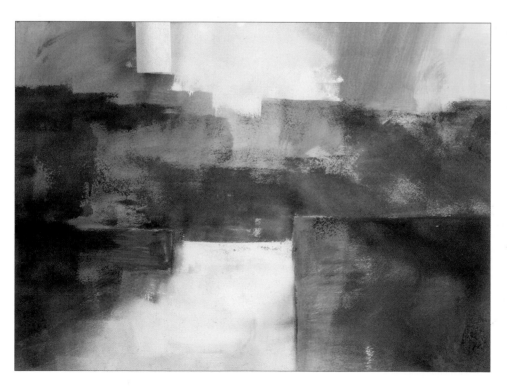

15 Use the edge of the roller to suggest sharp highlighting lines on the rooftops in the distance.

16 Accentuate the waterline by using the edge of the roller with titanium white to straighten the edge of the jetty and knock back the background.

17 Soften the wet white paint into the surface using a damp finger.

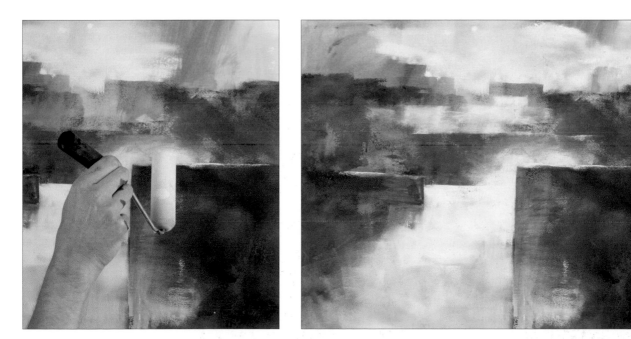

18 Add a highlight to the top of the right-hand jetty with the very corner of the roller.

19 Add a highlight to the top of the left-hand jetty in the same way, then develop the rooftop highlights with paint remaining on the roller.

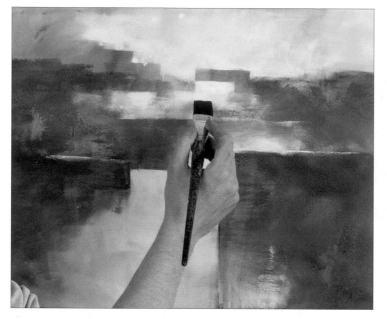

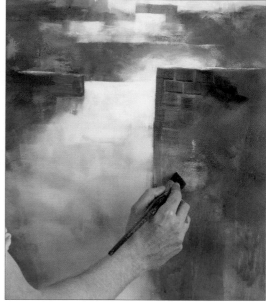

20 Apply titanium white with the edge of the size 28 short flat/bright to sharpen the highlights on the rooftops.

21 Dilute Winsor blue (green shade) with the same brush and block in some strong stone shapes on the jetties.

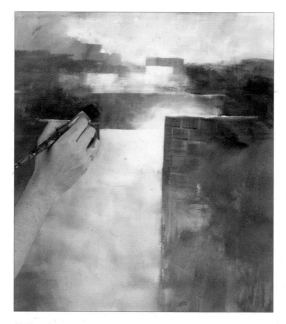

22 Scumble burnt sienna over the top left and top right building areas to knock them back. Add a little water and blend the colour in towards the centre with subtle glazes.

23 Still using the size 28 short flat/bright, dilute burnt sienna a great deal and add a warming glaze over the top left and top right of the sky.

24 Pick up titanium white on a scrunched-up piece of kitchen paper and rub a little in on the top left.

Tip

On consideration, I decided that I had put too much burnt sienna on the top left. However, acrylics are easy to correct, so adding some titanium white here brought the brightness back.

25 Glaze the left-hand quay with Winsor blue (green shade) and the size 28 short flat/bright.

26 Scumble burnt sienna over the whole of the right-hand jetty, working down from the top and allowing the paint to gradually run out as you reach the bottom.

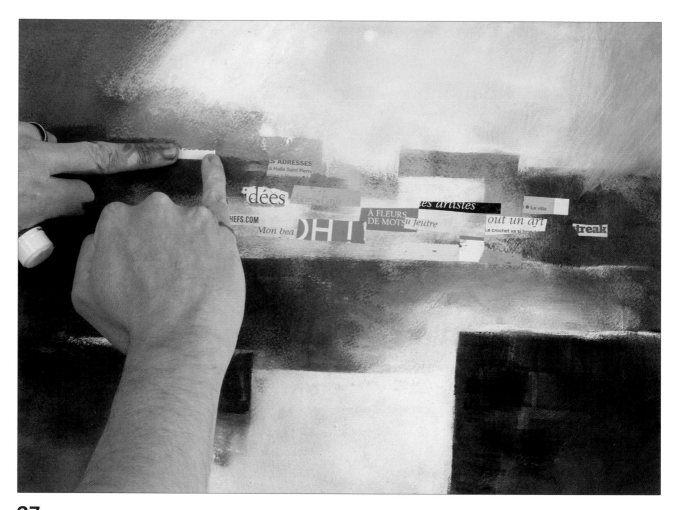

27 Gather a number of narrow strips, approximately 1cm (½in) in width, from your magazines. Select a variety of colours and attach them to the focal point with PVA glue.

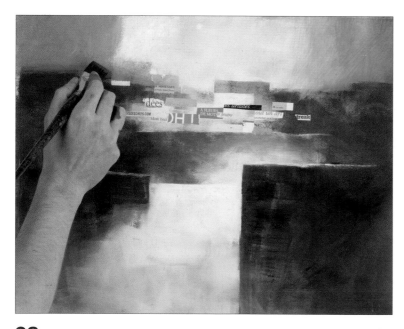

28 Mix Winsor blue (green shade) with titanium white and use a size 28 short/flat to scumble the paint in on the left-hand side of the sky.

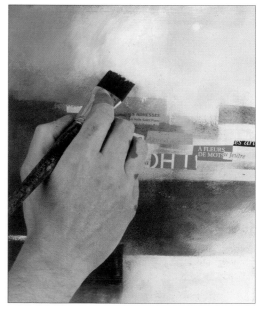

29 Clean the brush, shake it off and use the water remaining on the brush to draw the paint out across the white area of the sky.

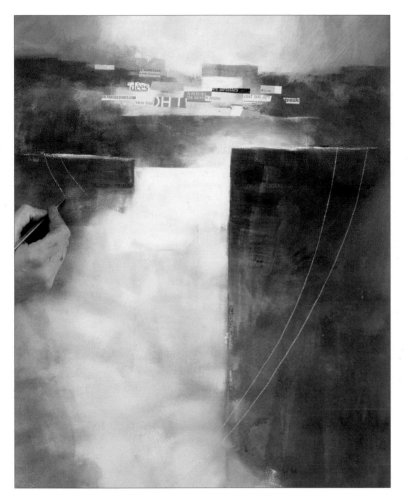

30 Scratch out mooring lines on the jetties by scraping the back edge of a craft knife blade across. Be careful not to cut into the painting by using the blade itself.

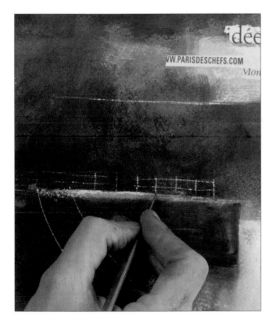

31 Create some railings on the left-hand jetty and tiny details across the background by scratching out some lines.

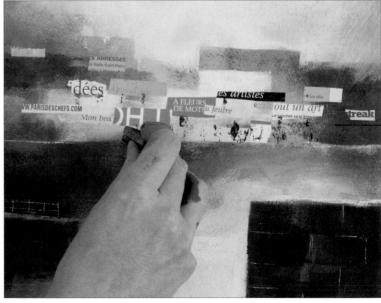

32 Make a dark mix of Winsor blue (green shade) and burnt sienna. Use a small bit of foam rubber to suggest some figures in the background.

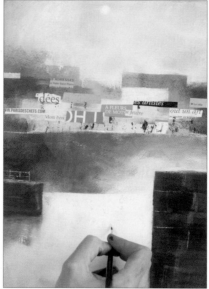

Tip

Hold a straight edge up to the sun to quickly find points directly beneath the sun.

33 Use the size 2 filbert to create a small sun near the top of the painting with titanium white.

34 Add white highlights directly underneath the sun to both the ground level of the town and the sea.

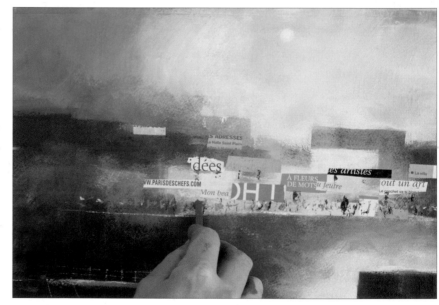

36 Add dots and dashes across the central quayside using red, pink, yellow and blue Conté sticks to add movement and interest to the focal point to finish.

35 Pick up dilute titanium white with your toothbrush. Hold the straight edge up to protect the right-hand jetty and spatter the water beneath the sun.

Opposite:

The finished painting

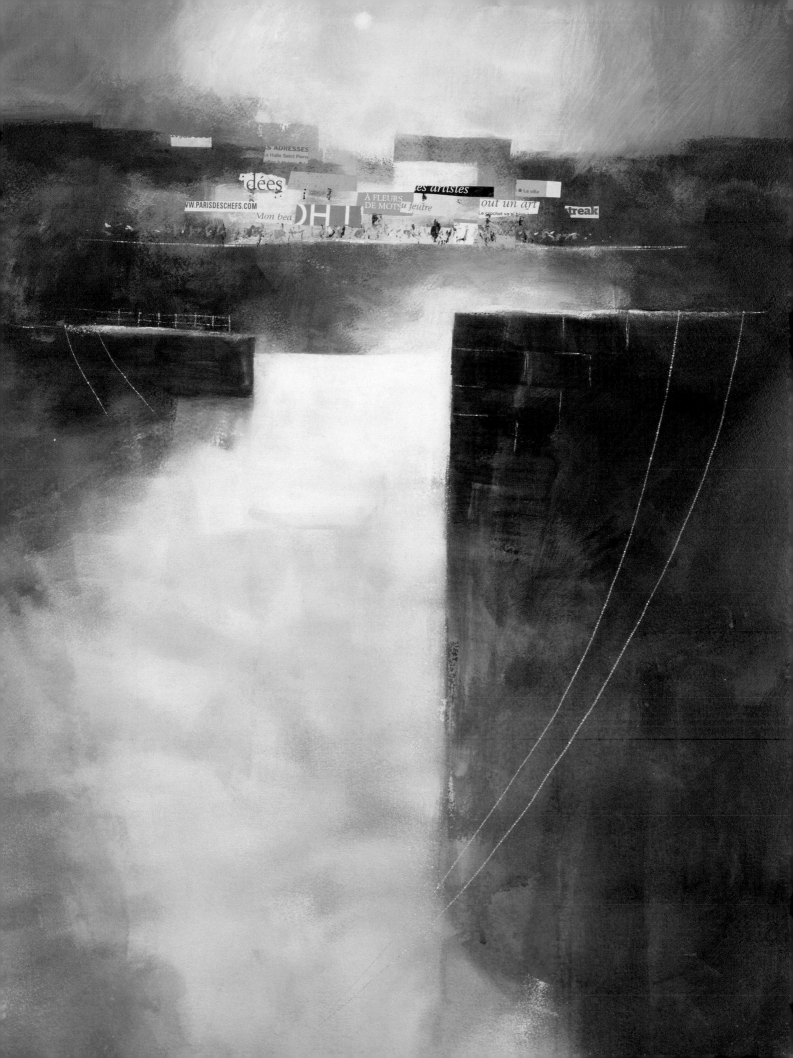

Poppy Field

For this painting I chose a beautiful field of poppies, which sway in the breeze on their long willowy stems creating patterns almost like the waves on the ocean. Flowers help to create a lot of movement in a painting, and a great way to understand that movement is to get amongst the action.

Capturing movement is not easy but applying loose areas of paint with sponges and rags helps to realise the transient nature of movement. When using such unconventional methods to apply paint, accidents will occur. These accidents can be happy accidents that fill you with joy and create painting magic or simply accidents that do not work! Fear not, acrylics are so versatile that even 'naughty accidents' can be brought under control by over-painting or simply wiping the offending marks away with a wet sponge.

You will need

Rough watercolour paper: 76 x 56cm (30 x 22in)

Paints: titanium white, ultramarine blue, cadmium red medium, phthalo turquoise, cadmium yellow medium, ultramarine blue

Brushes: size 8 short flat/ bright, size 2 filbert

Conté sticks: green, orange

4B pencil

Painting board and easel

Masking tape

Red-brown watersoluble pencil

Blue pencil

Sponge

1 Make a grid of 10cm (4in) squares using a red-brown watersoluble pencil, then lightly sketch the main shapes on to the watercolour paper using a blue pencil. Next, secure the paper to the board using masking tape and place it on your easel.

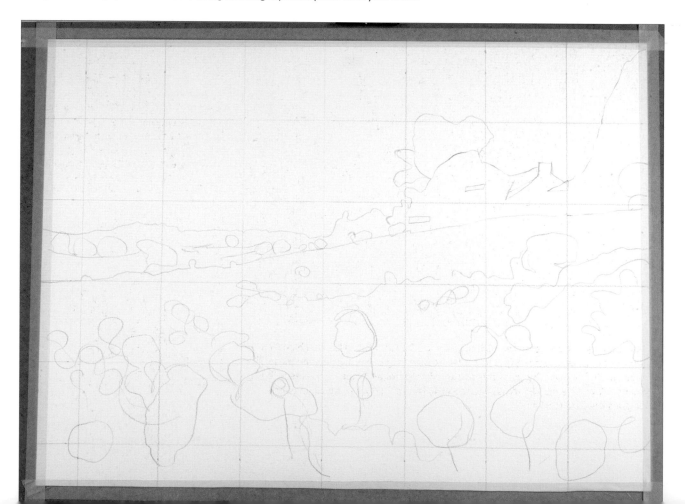

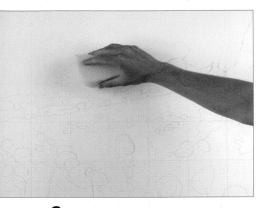

2 Use a damp household sponge to gently rub the watersoluble pencil grid from the sky area.

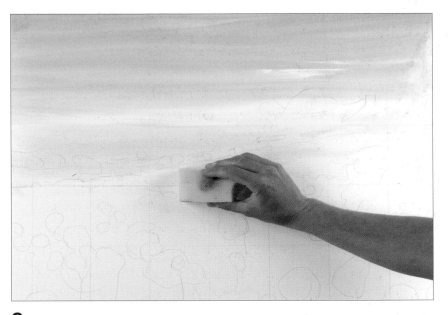

Tip

Taking the sky colour below the horizon creates tonal unity across the painting.

3 Make a dilute mix of titanium white and ultramarine blue. Pick up the mix on the sponge and use long horizontal strokes to apply it to the sky, working from the top down to slightly below the horizon.

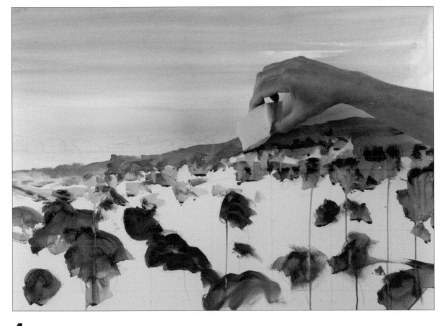

Tip

Using the edge and point of a sponge allows you more control to get stronger definition. You can also dance other parts of the sponge over the surface to give looser, lighter touches. I call this technique 'fairy fingers'!

4 Tear a sponge into a point and pick up cadmium red medium. Use it to block in the main poppies in the foreground, then dilute the paint slightly to suggest the mass of poppies on the horizon. This gives the colour a lighter tint and helps to create a sense of distance. It may seem odd to use the red now, but using it over the clean white paper gives the best vibrancy.

5 Add a little phthalo turquoise to cadmium yellow medium to create a bright green. Use a size 8 short flat/bright to apply a slightly diluted mix to the background. This allows the blue paint below to show through, creating an optical mix and giving greater clarity of colour.

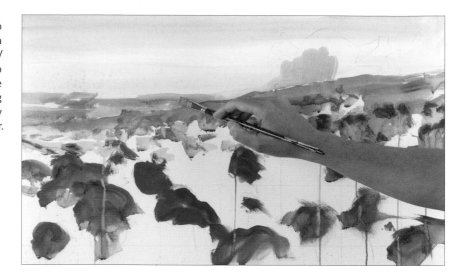

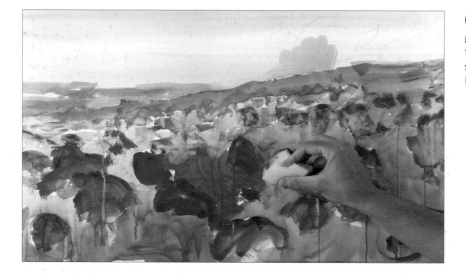

6 Use a fresh piece of sponge to apply gestural, calligraphic strokes of the green to the foreground. Bigger, more energetic strokes make things seem closer to you, helping to reinforce the sense of distance.

7 Use the edge of the sponge to run in lines of undiluted green fairly randomly to the foreground to suggest grass and flower stems. Use areas where paint has dripped down the painting to your advantage, reinforcing them to help suggest areas of shadow.

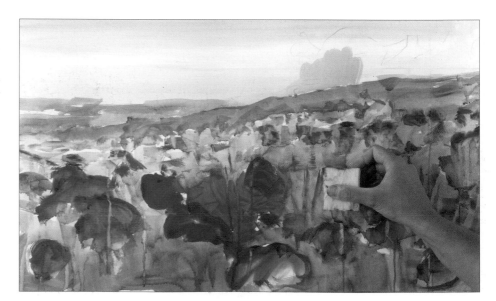

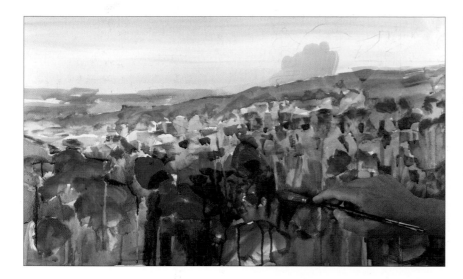

8 Add a touch of ultramarine blue to the green mix to darken it slightly, and use the size 8 short flat/bright to create shadow areas around the foreground. Use the paint fairly dilute, so that it runs and drips, but do not overdilute or you will lose the strength of colour.

9 Still using the size 8 short flat/ bright with the dilute green mix, press the brush on to the edges of the central poppy and twist it to create an area of shadow.

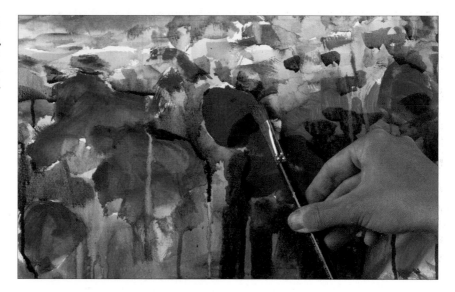

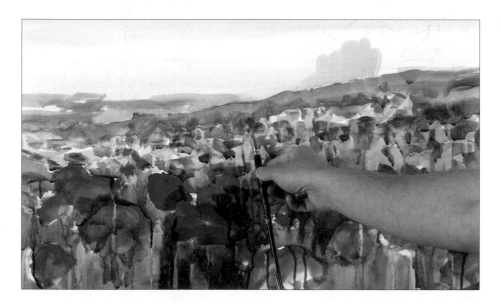

10 Repeat the process on the other large poppies in the foreground, then use the green mix – very diluted – to add light glazing touches to the background poppies.

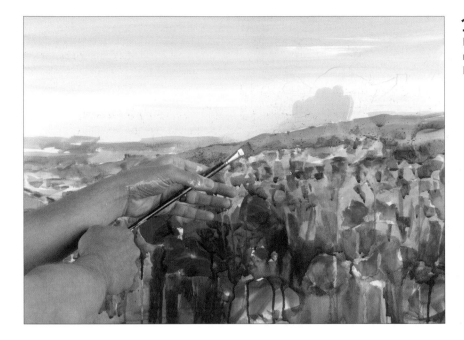

11 Spatter the very dilute green mix (a little phthalo turquoise, cadmium yellow medium and ultramarine blue) over the background field.

12 Make more of the dark green mix (cadmium yellow medium, phthalo turquoise and ultramarine blue). Use the size 8 short flat/bright to establish the dark area in the background, scrubbing the colour in undiluted. As the paint runs out, turn the brush side-on and use a dry brush technique to suggest foliage – the paint will pick out the surface texture of the paper (see inset).

13 Develop the darks in the foreground with the same mix, applying the mix with shorter, more controlled strokes.

14 Still using the same dark mix, use a size 2 filbert to pick out the chimney pots on the building in the top right-hand corner.

15 Use cadmium red medium neat from the tube to suggest the poppies in the background. Suggest the distance by making only small marks using the edge and corners of a fresh size 8 short flat brush.

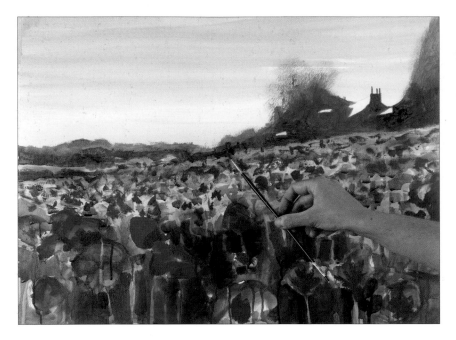

16 Still using neat cadmium red medium, break up the line between the back of the poppy field and the dark background by applying dots and dashes with the size 2 filbert.

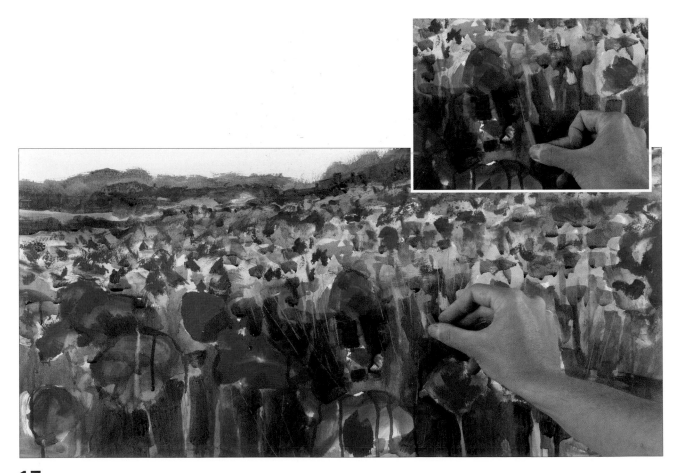

17 Allow the painting to dry thoroughly, then draw the sharp edge of a green Conté stick (see inset) to add some vertical strokes in the central foreground.

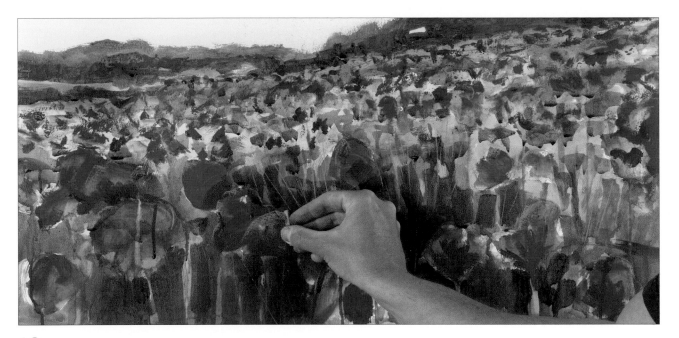

18 Pick out some highlights on the poppies using the orange Conté stick.

19 Darken the lower left foreground with the dilute dark green mix and the size 8 short flat/bright, then scrape out some stems below the poppy using the back of the brush to finish.

Overleaf:
The finished painting

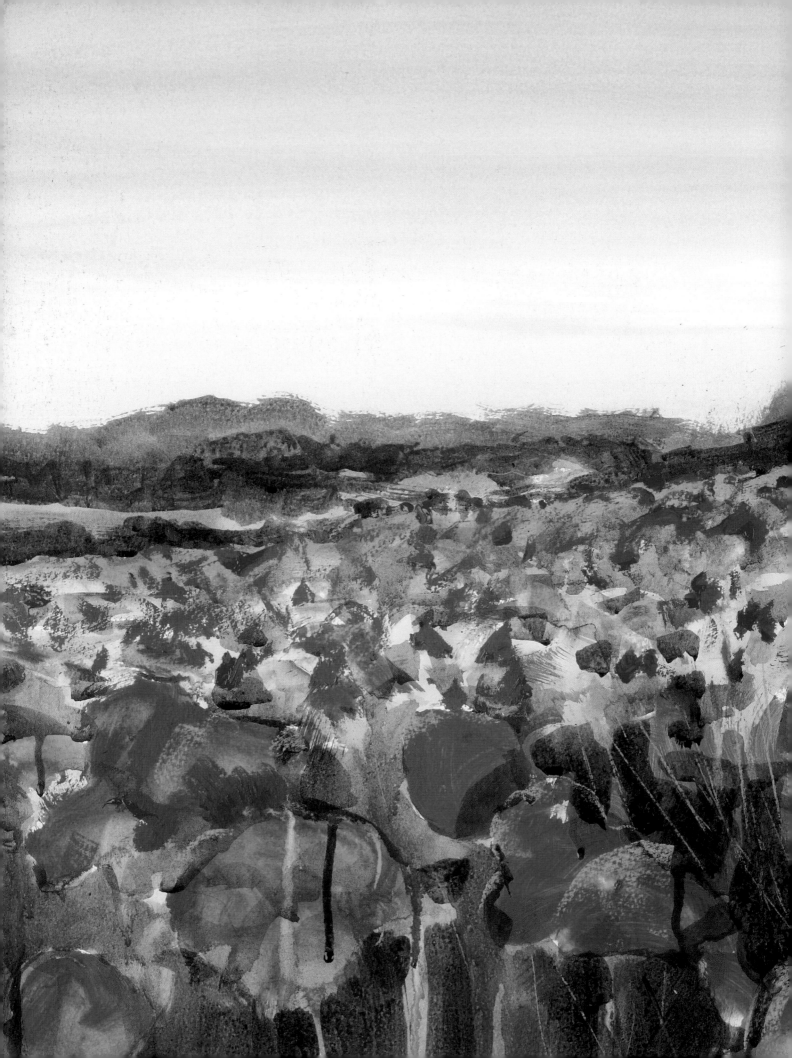

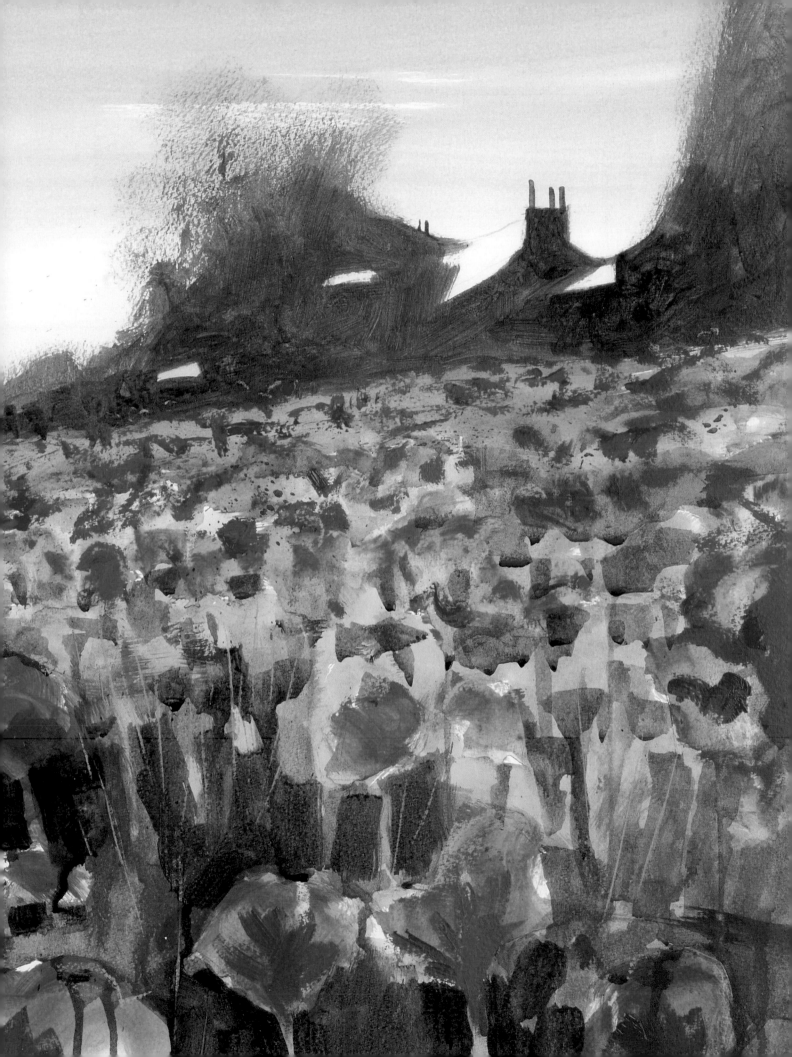

Seascape

Whether tranquil or tempestuous, the sea is a joy to paint in all of its moods; and acrylics seem made for capturing the atmosphere of the ocean beautifully. In the example shown here we glaze, drip, dribble, flick and spatter the paint. These activities can be difficult to achieve successfully using other media but are simple to achieve with acrylics.

This project also involves painting sideways – a good thing; and painting upside down is even better!

You will need

Rough watercolour paper: 76 x 56cm (30 x 22in)

Paints: burnt sienna, ultramarine blue, titanium white, Winsor blue (green shade), yellow ochre, cadmium red medium

Brushes: 50mm (2in) household brush, 25mm (1in) round varnishing brush, size 28 short flat/bright, size 2 round

Painting board and easel

Low-tack masking tape

Palette knife

4B pencil and straight edge

1 Use low-tack masking tape to secure a blank sheet of watercolour paper to the board and place the board on your easel. Add a touch of burnt sienna to ultramarine blue and dilute heavily. Pick up the mix with the 50mm (2in) household brush and draw a bold line all the way down the paper about a third of the way in from the left.

2 Without reloading the brush, work to the right, drawing more vertical strokes until you reach about three-quarters of the way across. This creates some broken lines as shown, which will represent the sea.

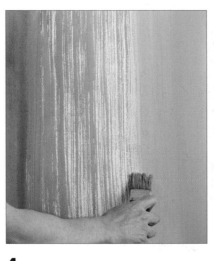

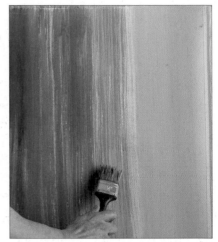

3 Add titanium white to the mix and paint the section to the right. Add Winsor blue (green shade) and blend the colour in on the far right. This will be the sky.

4 Rinse the brush and shake off any excess water. Use the damp brush to blend the break between the sea and sky with a single vertical stroke.

5 Add a touch more burnt sienna to the mix, dilute it further and glaze the right-hand section of sea, colouring the paper showing through and enriching the blue areas.

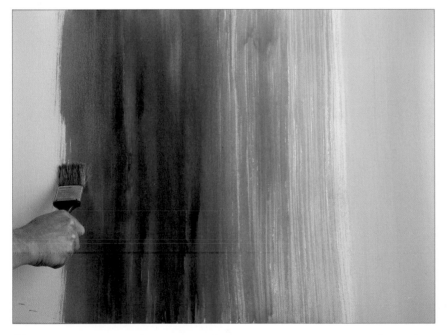

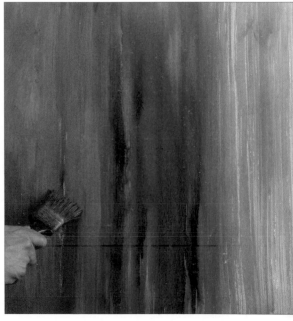

6 Still using the 50mm (2in) household brush, add more Winsor blue (green shade) and burnt sienna to deepen the mix, and glaze the left-hand section of the sea. Continue working to the left, using the same mix with fiercer strokes.

7 Clean your brush, load it with yellow ochre, and scumble the remaining space. This will be the foreshore. Blend the colour into the edge of the sea to avoid a sudden break.

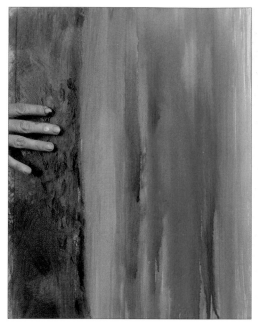

8 Load the brush with burnt sienna and scumble over the foreshore.

9 Mix Winsor blue (green shade) with burnt sienna and use your fingers to dab and smear the colour over the central part of the foreshore.

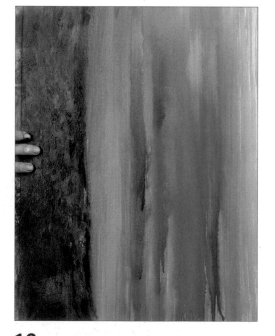

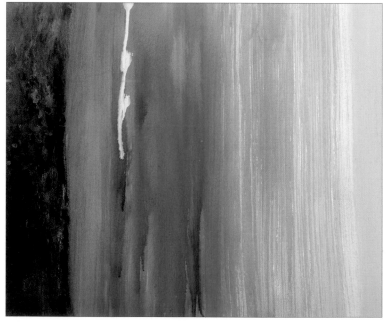

10 Continue to cover the foreshore with these textural marks, using larger marks as you work further to the left-hand edge.

11 Use a 25mm (1in) round varnishing brush to add dilute titanium white across the left-hand side of the sea and allow the paint to drip down the painting.

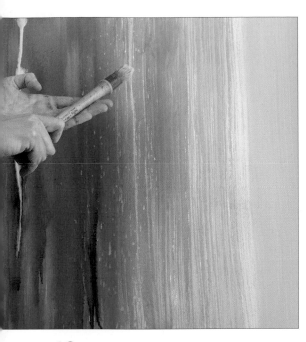

12 Use the paint remaining on the brush to spatter the sea area.

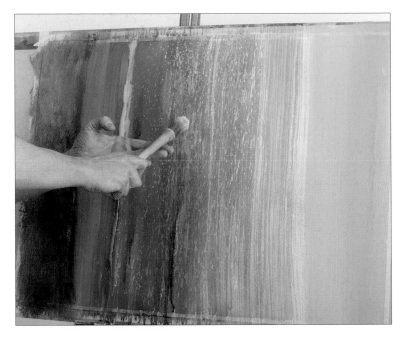

13 Continue to spatter the sea with dilute titanium white, aiming to create bands of heavier spattering along with lighter areas, in order to create a realistic effect.

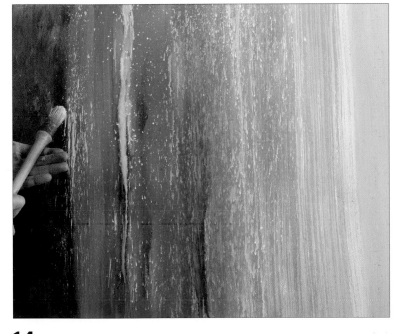

14 Spatter the right-hand side of the foreshore in the same way.

15 Blur the join between the sea and the foreshore using a palette knife and undiluted titanium white, drawing the paint down in streaks.

16 Identify lighter bands in the sea and highlight the right-hand sides using titanium white applied with the edge of the palette knife.

17 Further develop the foreground splash, then turn the board so the painting is upright. You may find you need to get the horizon flat, so measure down from the top to the horizon line and use a straight edge and 4B pencil to draw a faint line across.

18 Turn the board on its side and run low-tack masking tape down the pencil mark along the horizon, making sure it covers the sea, rather than the sky.

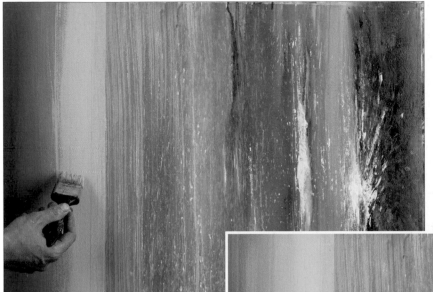

19 Pick up a mix of titanium white with a little ultramarine blue and paint up to and over the masking tape.

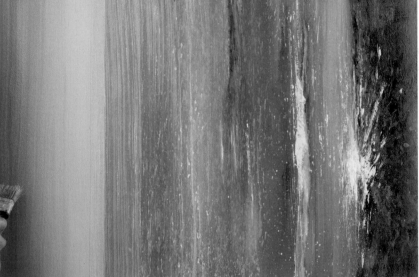

20 Dilute the mix and glaze towards the left-hand side, up into the top of the sky, blending the two areas together.

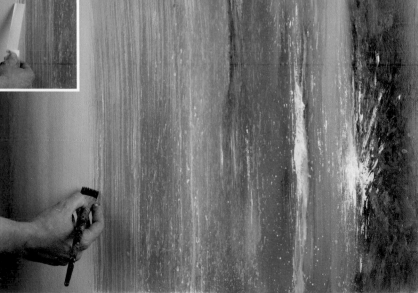

21 Quickly but carefully peel away the masking tape (see inset) and blend the horizon in with a damp size 28 short flat/bright. Allow the painting to dry thoroughly.

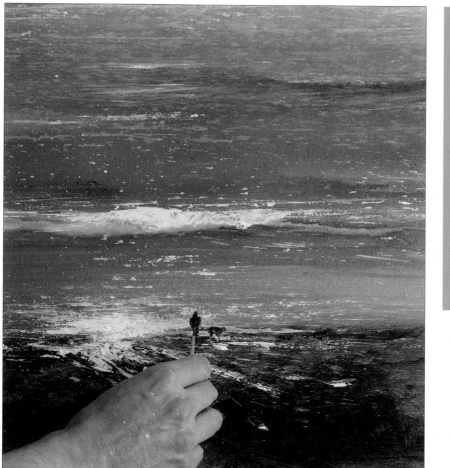

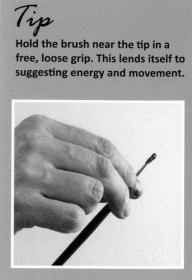
22 Make a dark mix from burnt sienna and Winsor blue (green shade) and pick it up on the size 2 round. Place a simple silhouetted figure and dog by the main spray area to create a sense of scale.

23 Pick up some of the light blue mix (titanium white and ultramarine blue) and subtly outline the figure.

24 Clean the brush and pick up pure cadmium red medium. Dot in a little hotspot on the figure to draw the eye and finish the painting.

Opposite:

The finished painting

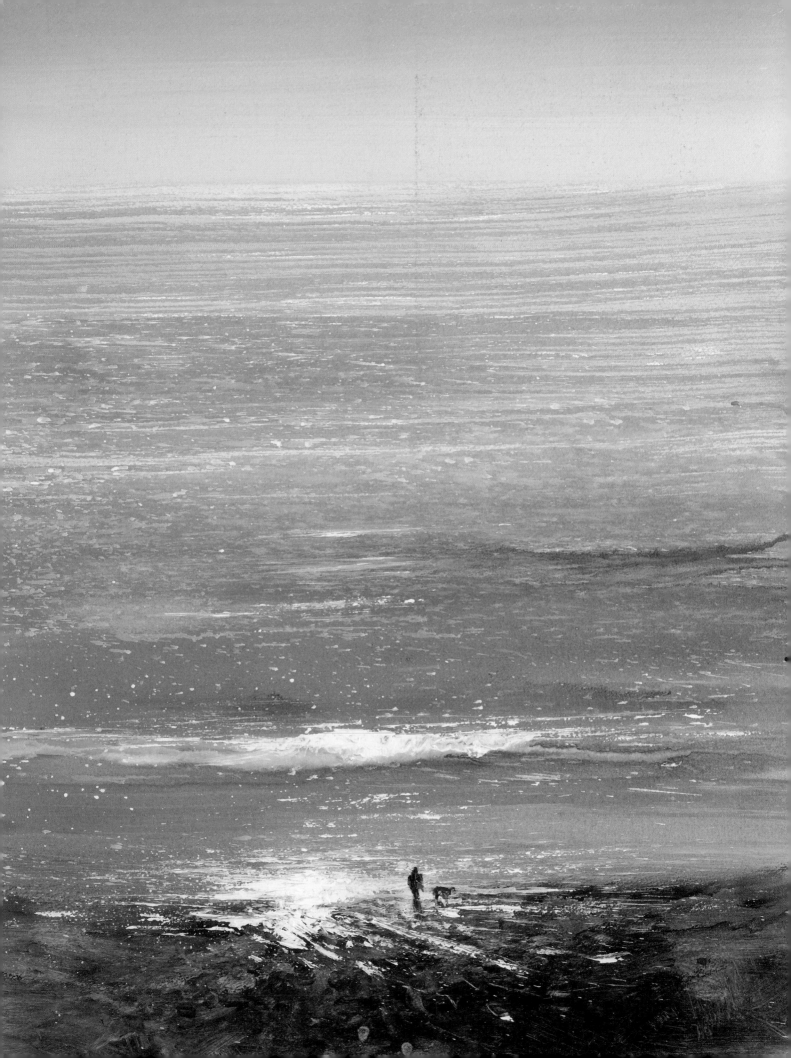

Index